Visions of the Daughters of Albion

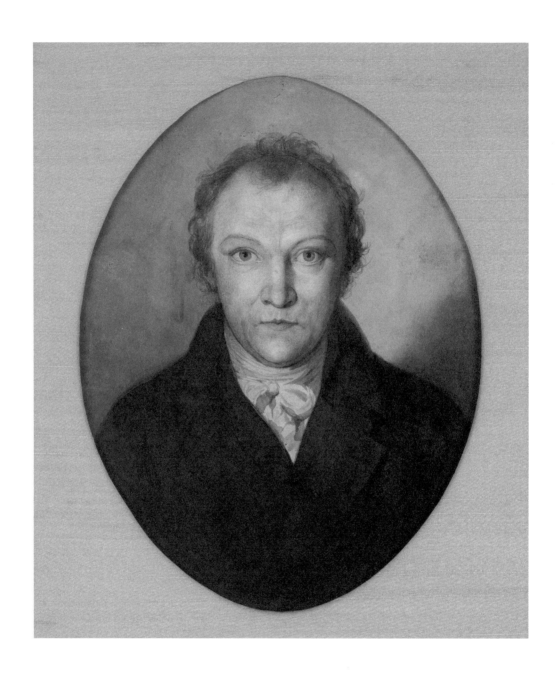

William Blake, Self-Portrait, c. 1802

WILLIAM BLAKE

VISIONS

of the Daughters of Albion

EDITED, WITH A COMMENTARY, BY

Robert N. Essick

Huntington Library

William Blake's *Visions of the Daughters of Albion* is reproduced
by permission from the copy in the Henry E. Huntington
Library. Drawings from William Blake's Notebook are repro-
duced by permission of the Manuscripts Department of the
British Library. The frontispiece illustration, a monochrome
wash drawing, is from the collection of Robert N. Essick.

© Copyright 2002 by the
Huntington Library and Art Gallery
1151 Oxford Road
San Marino, California 91108
626.405-2172
www.huntington.org

Library of Congress Cataloging-in-Publication Data

Blake, William, 1757-1827
 Visions of the daughters of Albion / William Blake; edited,
with a commentary, by Robert N. Essick.
 p. cm.
 Includes bibliographical references (p.) and index.
 isbn 0-87328-187-x
 I. Essick, Robert N. II. Title

PR 4144.V5 2002
821'.7— dc21 2001051909

Contents

Reproduction of Blake's Plates

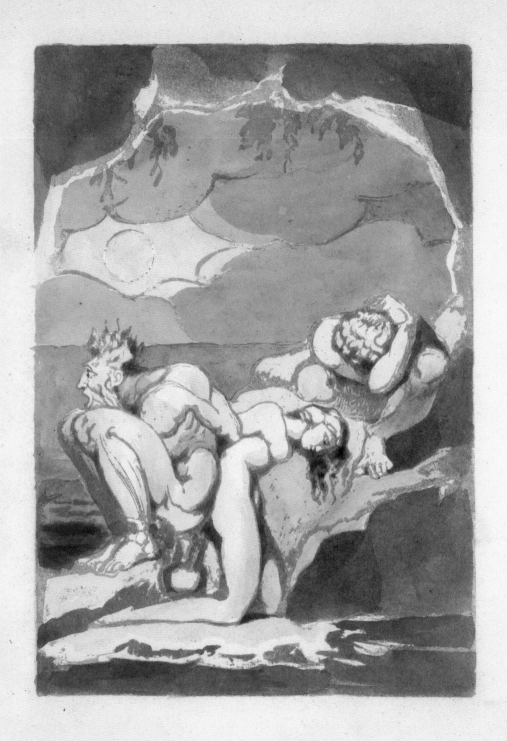

PLATE 1

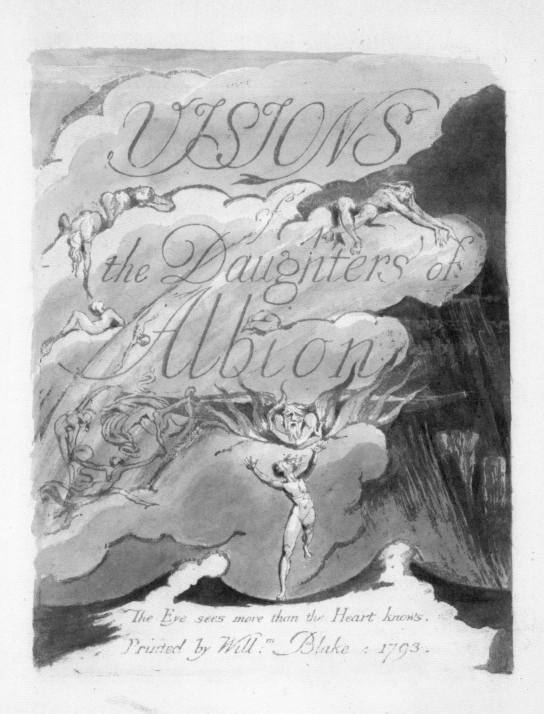

The Eye sees more than the Heart knows.
Printed by Will:^m Blake : 1793.

PLATE 2

The Argument

I loved Theotormon
And I was not ashamed
I trembled in my virgin fears
And I hid in Leutha's vale!

I plucked Leutha's flower,
And I rose up from the vale:
But the terrible thunders tore
My virgin mantle in twain.

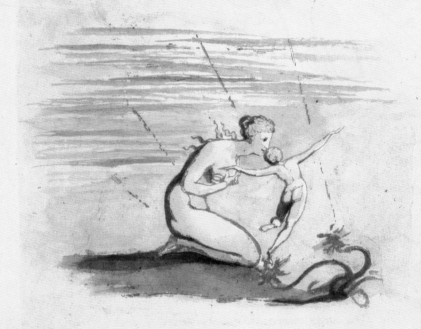

PLATE 3

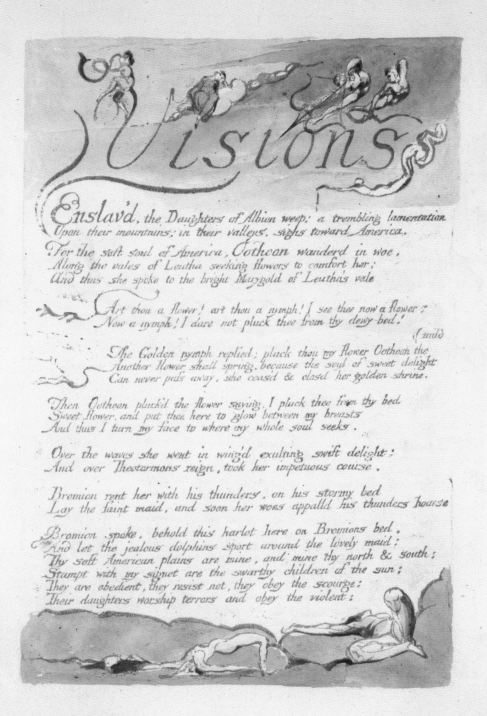

Visions

Enslav'd, the Daughters of Albion weep: a trembling lamentation
Upon their mountains; in their valleys, sighs toward America.

For the soft soul of America, Oothoon wanderd in woe,
Along the vales of Leutha seeking flowers to comfort her;
And thus she spoke to the bright Marygold of Leutha's vale

Art thou a flower! art thou a nymph! I see thee now a flower;
Now a nymph! I dare not pluck thee from thy dewy bed!

(mild

The Golden nymph replied; pluck thou my Flower Oothoon the
Another flower shall spring, because the soul of sweet delight
Can never pass away. she ceasd & closd her golden shrine.

Then Oothoon pluckd the flower saying, I pluck thee from thy bed
Sweet flower, and put thee here to glow between my breasts
And thus I turn my face to where my whole soul seeks.

Over the waves she went in wing'd exulting swift delight;
And over Theotormons reign, took her impetuous course.

Bromion rent her with his thunders, on his stormy bed
Lay the faint maid, and soon her woes appalld his thunders hoarse

Bromion spoke. behold this harlot here on Bromions bed,
And let the jealous dolphins sport around the lovely maid;
Thy soft American plains are mine, and mine thy north & south:
Stampt with my signet are the swarthy children of the sun:
They are obedient, they resist not, they obey the scourge:
Their daughters worship terrors and obey the violent:

PLATE 4

Now thou must marry Bromions harlot. and protect the child
Of Bromions rage, that Oothoon shall put forth in nine moons
time

Then storms rent Theotormons limbs; he rolld his waves around,
And folded his black jealous waters round the adulterate pair
Bound back to back in Bromions caves terror & meeknels dwell

At entrance Theotormon sits wearing the threshold hard
With secret tears; beneath him sound like waves on a desart shore
The voice of slaves beneath the sun, and children bought with money,
That shiver in religious caves beneath the burning fires
Of lust, that belch incessant from the summits of the earth

Oothoon weeps not, she cannot weep! her tears are locked up;
But she can howl incessant writhing her soft snowy limbs,
And calling Theotormons Eagles to prey upon her flesh.

I call with holy voice! kings of the sounding air,
Rend away this defiled bosom that I may reflect,
The image of Theotormon on my pure transparent breast.

The Eagles at her call descend & rend their bleeding prey;
Theotormon severely smiles, her soul reflects the smile;
As the clear spring mudded with feet of beasts grows pure & smiles.

The Daughters of Albion hear her woes, & eccho back her sighs.

Why does my Theotormon sit weeping upon the threshold;
And Oothoon hovers by his side, perswading him in vain;
I cry arise O Theotormon for the village dog
Barks at the breaking day, the nightingale has done lamenting,
The lark does rustle in the ripe corn, and the Eagle returns
From nightly prey, and lifts his golden beak to the pure east;
Shaking the dust from his immortal pinions to awake
The sun that sleeps too long. Arise my Theotormon I am pure,
Because the night is gone that closd me in its deadly black.
They told me that the night & day were all that I could see;
They told me that I had five senses to inclose me up,
And they inclos'd my infinite brain into a narrow circle,
And sunk my heart into the Abyss, a red round globe hot burning
Till all from life I was obliterated and erased.
Instead of morn arises a bright shadow, like an eye
In the eastern cloud; instead of night a sickly charnel house;
That Theotormon hears me not! to him the night and morn
Are both alike; a night of sighs, a morning of fresh tears;

PLATE 5

And none but Bromion can hear my lamentations.

With what sense is it that the chicken shuns the ravenous hawk?
With what sense does the tame pigeon measure out the expanse?
With what sense does the bee form cells? have not the mouse & frog
Eyes and ears and sense of touch? yet are their habitations.
And their pursuits, as different as their forms and as their joys:
Ask the wild ass why he refuses burdens: and the meek camel
Why he loves man: is it because of eye ear mouth or skin
Or breathing nostrils? No, for these the wolf and tyger have.
Ask the blind worm the secrets of the grave, and why her spires
Love to curl round the bones of death; and ask the ravnous snake
Where she gets poison: & the wing'd eagle why he loves the sun
And then tell me the thoughts of man, that have been hid of old.

Silent I hover all the night, and all day could be silent.
If Theotormon once would turn his loved eyes upon me;
How can I be defild when I reflect thy image pure?
Sweetest the fruit that the worm feeds on. & the soul prey'd on by woe
The new wash'd lamb ting'd with the village smoke & the bright swan
By the red earth of our immortal river: I bathe my wings,
And I am white and pure to hover round Theotormons breast.

Then Theotormon broke his silence, and he answered.

Tell me what is the night or day to one oerflowd with woe?
Tell me what is a thought? & of what substance is it made?
Tell me what is a joy? & in what gardens do joys grow?
And in what rivers swim the sorrows? and upon what mountains

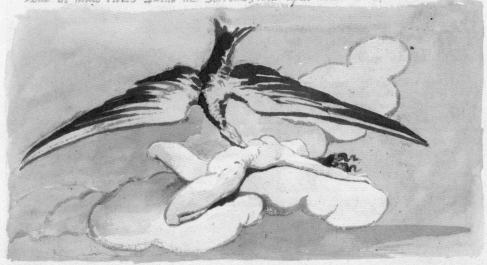

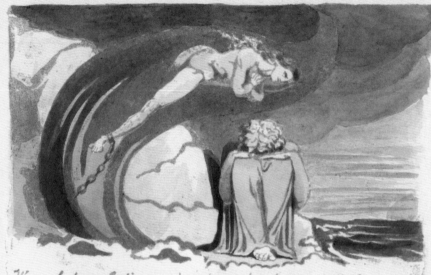

Wave shadows of discontent! and in what houses dwell the wretched
Drunken with woe forgotten, and shut up from cold despair.

Tell me where dwell the thoughts forgotten till thou call them forth
Tell me where dwell the joys of old! & where the ancient loves?
And when will they renew again & the night of oblivion past?
That I might traverse times & spaces far remote and bring
Comforts into a present sorrow and a night of pain,
Where goest thou O thought! to what remote land is thy flight?
If thou returnest to the present moment of affliction
Wilt thou bring comforts on thy wings, and dews and honey and balm;
Or poison from the desart wilds, from the eyes of the envier.

Then Bromion said: and shook the cavern with his lamentation

Thou knowest that the ancient trees seen by thine eyes have fruit;
But knowest thou that trees and fruits flourish upon the earth
To gratify senses unknown? trees beasts and birds unknown:
Unknown, not unpercievd, spread in the infinite microscope,
In places yet unvisited by the voyager, and in worlds
Over another kind of seas, and in atmospheres unknown:
Ah! are there other wars, beside the wars of sword and fire!
And are there other sorrows, beside the sorrows of poverty!
And are there other joys, beside the joys of riches and ease?
And is there not one law for both the lion and the ox!
And is there not eternal fire, and eternal chains?
To bind the phantoms of existence from eternal life?

Then Oothoon waited silent all the day, and all the night,

PLATE 7

But when the morn arose, her lamentation renewd,
The Daughters of Albion hear her woes, & eccho back her sighs.

O Urizen! Creator of men! mistaken Demon of heaven;
Thy joys are tears! thy labour vain, to form men to thine image.
How can one joy absorb another? are not different joys
Holy, eternal, infinite! and each joy is a Love.

Does not the great mouth laugh at a gift! & the narrow eyelids mock
At the labour that is above payment, and wilt thou take the ape
For thy councellor? or the dog, for a schoolmaster to thy children?
Does he who contemns poverty, and he who turns with abhorrence
From usury; feel the same passion or are they moved alike?
How can the giver of gifts experience the delights of the merchant?
How the industrious citizen the pains of the husbandman.
How different far the fat fed hireling with hollow drum;
Who buys whole corn fields into wastes, and sings upon the heath:
How different their eye and ear! how different the world to them!
With what sense does the parson claim the labour of the farmer?
What are his nets & gins & traps, & how does he surround him
With cold floods of abstraction, and with forests of solitude,
To build him castles and high spires, where kings & priests may dwell.
Till she who burns with youth, and knows no fixed lot; is bound
In spells of law to one she loaths: and must she drag the chain
Of life, in weary lust! must chilling murderous thoughts, obscure
The clear heaven of her eternal spring? to bear the wintry rage
Of a harsh terror drivn to madness, bound to hold a rod
Over her shrinking shoulders all the day; & all the night
To turn the wheel of false desire: and longings that wake her womb
To the abhorred birth of cherubs in the human form
That live a pestilence & die a meteor & are no more.
Till the child dwell with one he hates, and do the deed he loaths
And the impure scourge force his seed into its unripe birth
E'er yet his eyelids can behold the arrows of the day.

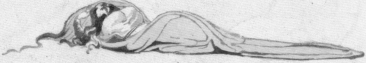

Does the whale worship at thy footsteps as the hungry dog?
Or does he scent the mountain prey, because his nostrils wide
Draw in the ocean? does his eye discern the flying cloud
As the ravens eye? or does he measure the expanse like the vulture?
Does the still spider view the cliffs where eagles hide their young?
Or does the fly rejoice, because the harvest is brought in?
Does not the eagle scorn the earth & despise the treasures beneath?
But the mole knoweth what is there, & the worm shall tell it thee.
Does not the worm erect a pillar in the mouldering church yard?

PLATE 8

And a palace of eternity in the jaws of the hungry grave
Over his porch these words are written. Take thy bliss O Man!
And sweet shall be thy taste & sweet thy infant joys renew!

Infancy, fearless, lustful, happy! nestling for delight
In laps of pleasure; Innocence! honest, open, seeking
The vigorous joys of morning light; open to virgin bliss.
Who taught thee modesty, subtil modesty! child of night & sleep
When thou awakest, wilt thou dissemble all thy secret joys
Or wert thou not awake when all this mystery was disclos'd!
Then comst thou forth a modest virgin knowing to dissemble
With nets found under thy night pillow, to catch virgin joy,
And brand it with the name of whore; & sell it in the night,
In silence, ev'n without a whisper, and in seeming sleep.
Religious dreams and holy vespers, light thy smoky fires:
Once were thy fires lighted by the eyes of honest morn
And does my Theotormon seek this hypocrite modesty!
This knowing, artful, secret, fearful, cautious, trembling hypocrite.
Then is Oothoon a whore indeed! and all the virgin joys
Of life are harlots: and Theotormon is a sick mans dream
And Oothoon is the crafty slave of selfish holiness.

But Oothoon is not so, a virgin fill'd with virgin fancies
Open to joy and to delight where ever beauty appears
If in the morning sun I find it: there my eyes are fix'd

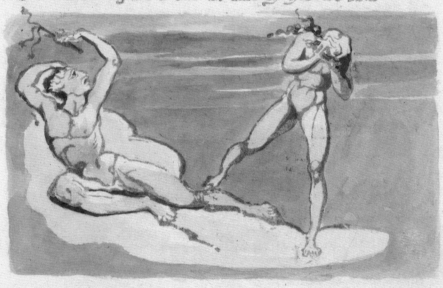

PLATE 9

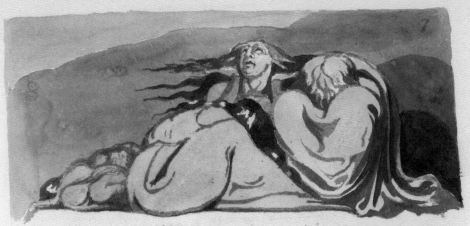

In happy copulation; if in evening mild, wearied with work;
Sit on a bank and draw the pleasures of this free born joy.

The moment of desire! the moment of desire! The virgin
That pines for man; shall awaken her womb to enormous joys
In the secret shadows of her chamber; the youth shut up from
The lustful joy, shall forget to generate. & create an amorous image
In the shadows of his curtains and in the folds of his silent pillow.
Are not these the places of religion? the rewards of continence?
The self enjoyings of self denial? Why dost thou seek religion?
Is it because acts are not lovely, that thou seekest solitude,
Where the horrible darkness is impressed with reflections of desire.

Father of Jealousy, be thou accursed from the earth!
Why hast thou taught my Theotormon this accursed thing?
Till beauty fades from off my shoulders darken'd and cast out,
A solitary shadow wailing on the margin of non-entity.

I cry, Love! Love! Love! happy happy Love! free as the mountain wind!
Can that be Love, that drinks another as a sponge drinks water?
That clouds with jealousy his nights, with weepings all the day:
To spin a web of age around him, grey and hoary! dark!
Till his eyes sicken at the fruit that hangs before his sight.
Such is self-love that envies all! a creeping skeleton
With lamplike eyes watching around the frozen marriage bed.

But silken nets and traps of adamant will Oothoon spread,
And catch for thee girls of mild silver, or of furious gold;
I'll lie beside thee on a bank & view their wanton play
In lovely copulation bliss on bliss with Theotormon:
Red as the rosy morning, lustful as the first born beam,
Oothoon shall view his dear delight, nor e'er with jealous cloud
Come in the heaven of generous love; nor selfish blightings bring.

Does the sun walk in glorious raiment, on the secret floor

PLATE 10

Where the cold miser spreads his gold? or does the bright cloud
On his stone threshold? does his eye behold the beam that brings
Expansion to the eye of pity? or will he bind himself
Beside the ox to thy hard furrow? does not that mild beam blot
The bat, the owl, the glowing tyger, and the king of night.
The sea fowl takes the wintry blast, for a covering to her limbs:
And the wild snake, the pestilence to adorn him with gems & gold.
And trees & birds, & beasts, & men, behold their eternal joy.
Arise you little glancing wings, and sing your infant joy!
Arise and drink your bliss, for every thing that lives is holy!

Thus every morning wails Oothoon, but Theotormon sits
Upon the margind ocean conversing with shadows dire.

The Daughters of Albion hear her woes, & eccho back her sighs.

The End

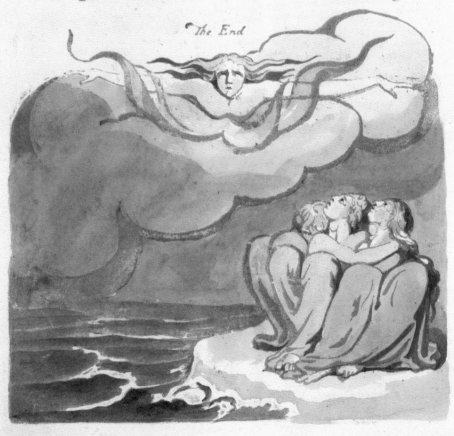

PLATE 11

Transcription of the Poem

[PLATE 2, TITLE PAGE]

VISIONS
of
the Daughters of

Albion

The Eye sees more than the Heart knows.

Printed by Will:^m Blake : 1793.

[PLATE 3]

The Argument

I loved Theotormon
And I was not ashamed
I trembled in my virgin fears
And I hid in Leutha's vale!

I plucked Leutha's flower, 5
And I rose up from the vale;
But the terrible thunders tore
My virgin mantle in twain.

[PLATE 4]

Visions

Enslav'd, the Daughters of Albion weep; a trembling lamentation

Upon their mountains; in their valleys, sighs toward America.

For the soft soul of America, Oothoon wanderd in woe,

Along the vales of Leutha seeking flowers to comfort her;

And thus she spoke to the bright Marygold of Leutha's vale 5

Art thou a flower! art thou a nymph! I see thee now a flower;

Now a nymph! I dare not pluck thee from thy dewy bed!

 (mild

The Golden nymph replied; pluck thou my flower Oothoon the

Another flower shall spring. because the soul of sweet delight

Can never pass away, she ceas'd & closd her golden shrine. 10

Then Oothoon pluck'd the flower saying, I pluck thee from thy bed

Sweet flower. and put thee here to glow between my breasts

And thus I turn my face to where my whole soul seeks.

Over the waves she went in wing'd exulting swift delight;

And over Theotormons reign, took her impetuous course. 15

Bromion rent her with his thunders. on his stormy bed

Lay the faint maid, and soon her woes appalld his thunders hoarse

Bromion spoke, behold this harlot here on Bromions bed.

And let the jealous dolphins sport around the lovely maid;

Thy soft American plains are mine, and mine thy north & south: 20

Stampt with my signet are the swarthy children of the sun:

They are obedient, they resist not, they obey the scourge:

Their daughters worship terrors and obey the violent:

[PLATE 5]

2

Now thou maist marry Bromions harlot, and protect the child

Of Bromions rage, that Oothoon shall put forth in nine moons

time

Then storms rent Theotormons limbs: he rolld his waves around.

And folded his black jealous waters round the adulterate pair

Bound back to back in Bromions caves terror & meekness dwell 5

At entrance Theotormon sits wearing the threshold hard

With secret tears; beneath him sound like waves on a desart shore

The voice of slaves beneath the sun, and children bought with money,

That shiver in religious caves beneath the burning fires

Of lust, that belch incessant from the summits of the earth 10

Oothoon weeps not. she cannot weep! her tears are locked up;

But she can howl incessant writhing her soft snowy limbs.

And calling Theotormons Eagles to prey upon her flesh.

I call with holy voice! kings of the sounding air.

Rend away this defiled bosom that I may reflect. 15

The image of Theotormon on my pure transparent breast.

 The Eagles at her call descend & rend their bleeding prey;

 Theotormon severely smiles. her soul reflects the smile;

 As the clear spring mudded with feet of beasts grows pure & smiles

The Daughters of Albion hear her woes. & eccho back her sighs. 20

Why does my Theotormon sit weeping upon the threshold:

And Oothoon hovers by his side, perswading him in vain:

I cry arise O Theotormon for the village dog

Barks at the breaking day. the nightingale has done lamenting,

The lark does rustle in the ripe corn, and the Eagle returns 25

From nightly prey; and lifts his golden beak to the pure east;

Shaking the dust from his immortal pinions to awake

The sun that sleeps too long. Arise my Theotormon I am pure.

Because the night is gone that clos'd me in its deadly black.

They told me that the night & day were all that I could see: 30

They told me that I had five senses to inclose me up.

And they inclos'd my infinite brain into a narrow circle.

And sunk my heart into the Abyss. a red round globe hot burning

Till all from life I was. obliterated and erased.

Instead of morn arises a bright shadow. like an eye 35

In the eastern cloud: instead of night a sickly charnel house:

That Theotormon hears. me not! to him the night and morn

Are both alike: a night of sighs, a morning of fresh tears;

[PLATE 6]

3

And none but Bromion can hear my lamentations.

With what sense is it that the chicken shuns the ravenous hawk?

With what sense does the tame pigeon measure out the expanse?

With what sense does the bee form cells? have not the mouse & frog

Eyes and ears and sense of touch? yet are their habitations. 5

And their pursuits, as different as their forms and as their joys:

Ask the wild ass why he refuses burdens: and the meek camel

Why he loves man: is it because of eye ear mouth or skin

Or breathing nostrils? No, for these the wolf and tyger have.

Ask the blind worm the secrets of the grave, and why her spires 10

Love to curl round the bones of death! and ask the rav'nous snake

Where she gets poison: & the wing'd eagle why he loves the sun

And then tell me the thoughts of man, that have been hid of old.

Silent I hover all the night, and all day could be silent.

If Theotormon once would turn his loved eyes upon me; 15

How can I be defild when I reflect thy image pure? (woe

Sweetest the fruit that the worm feeds on. & the soul prey'd on by

The new wash'd lamb ting'd with the village smoke & the bright swan

By the red earth of our immortal river: I bathe my wings,

And I am white and pure to hover round Theotormons breast. 20

Then Theotormon broke his silence. and he answered.

Tell me what is the night or day to one o'erflowd with woe?

Tell me what is a thought? & of what substance is it made?

Tell me what is a joy? & in what gardens do joys grow?

And in what rivers swim the sorrows? and upon what mountains 25

[PLATE 7]

Wave shadows of discontent? and in what houses dwell the wretched

Drunken with woe forgotten. and shut up from cold despair,

Tell me where dwell the thoughts forgotten till thou call them forth

Tell me where dwell the joys of old? & where the ancient loves?

And when will they renew again & the night of oblivion past? 5

That I might traverse times & spaces far remote and bring

Comforts into a present sorrow and a night of pain

Where goest thou O thought! to what remote land is thy flight?

If thou returnest to the present moment of affliction

Wilt thou bring comforts on thy wings. and dews and honey and balm; 10

Or poison from the desart wilds, from the eyes of the envier.

Then Bromion said; and shook the cavern with his lamentation

Thou knowest that the ancient trees seen by thine eyes have fruit;

But knowest thou that trees and fruits flourish upon the earth

To gratify senses unknown? trees beasts and birds unknown: 15

Unknown, not unpercievd, spread in the infinite microscope,

In places yet unvisited by the voyager. and in worlds

Over another kind of seas. and in atmospheres unknown:

Ah! are there other wars. beside the wars of sword and fire!

And are there other sorrows, beside the sorrows of poverty? 20

And are there other joys, beside the joys of riches and ease?

And is there not one law for both the lion and the ox?

And is there not eternal fire, and eternal chains?

To bind the phantoms of existence from eternal life?

Then Oothoon waited silent all the day, and all the night, 25

[PLATE 8]

5

But when the morn arose. her lamentation renewd,

The Daughters of Albion hear her woes, & eccho back her sighs.

O Urizen! Creator of men! mistaken Demon of heaven;

Thy joys are tears! thy labour vain, to form men to thine image.

How can one joy absorb another? are not different joys 5

Holy, eternal, infinite! and each joy is a Love.

Does not the great mouth laugh at a gift? & the narrow eyelids mock

At the labour that is above payment, and wilt thou take the ape

For thy councellor? or the dog. for a schoolmaster to thy children?

Does he who contemns poverty, and he who turns with abhorrence 10

From usury: feel the same passion or are they moved alike?

How can the giver of gifts experience the delights of the merchant?

How the industrious citizen the pains of the husbandman.

How different far the fat fed hireling with hollow drum;

Who buys whole corn fields into wastes, and sings upon the heath: 15

How different their eye and ear! how different the world to them!

With what sense does the parson claim the labour of the farmer?

What are his nets & gins & traps, & how does he surround him

With cold floods of abstraction, and with forests of solitude,

To build him castles and high spires, where kings & priests may dwell. 20

Till she who burns with youth. and knows no fixed lot; is bound

In spells of law to one she loaths: and must she drag the chain

Of life, in weary lust! must chilling murderous thoughts. obscure

The clear heaven of her eternal spring! to bear the wintry rage

Of a harsh terror driv'n to madness, bound to hold a rod 25

Over her shrinking shoulders all the day; & all the night

To turn the wheel of false desire: and longings that wake her womb

To the abhorred birth of cherubs in the human form

That live a pestilence & die a meteor & are no more.

Till the child dwell with one he hates. and do the deed he loaths 30

And the impure scourge force his seed into its unripe birth

E'er yet his eyelids can behold the arrows of the day.

Does the whale worship at thy footsteps as the hungry dog?

Or does he scent the mountain prey, because his nostrils wide

Draw in the ocean? does his eye discern the flying cloud 35

As the ravens eye? or does he measure the expanse like the vulture?

Does the still spider view the cliffs where eagles hide their young?

Or does the fly rejoice. because the harvest is brought in?

Does not the eagle scorn the earth & despise the treasures beneath?

But the mole knoweth what is there, & the worm shall tell it thee. 40

Does not the worm erect a pillar in the mouldering church yard?

[PLATE 9]

6

And a palace of eternity in the jaws of the hungry grave

Over his porch these words are written. Take thy bliss O Man!

And sweet shall be thy taste & sweet thy infant joys renew!

Infancy, fearless, lustful, happy! nestling for delight

In laps of pleasure; Innocence! honest, open, seeking 5

The vigorous joys of morning light; open to virgin bliss.

Who taught thee modesty, subtil modesty! child of night & sleep

When thou awakest. wilt thou dissemble all thy secret joys

Or wert thou not awake when all this mystery was disclos'd!

Then com'st thou forth a modest virgin knowing to dissemble 10

With nets found under thy night pillow, to catch virgin joy,

And brand it with the name of whore: & sell it in the night,

In silence. ev'n without a whisper, and in seeming sleep.

Religious dreams and holy vespers, light thy smoky fires:

Once were thy fires lighted by the eyes of honest morn 15

And does my Theotormon seek this hypocrite modesty!

This knowing. artful, secret. fearful, cautious, trembling hypocrite.

Then is Oothoon a whore indeed! and all the virgin joys

Of life are harlots: and Theotormon is a sick mans dream

And Oothoon is the crafty slave of selfish holiness. 20

But Oothoon is not so. a virgin fill'd with virgin fancies

Open to joy and to delight where ever beauty appears

If in the morning sun I find it: there my eyes are fix'd

[PLATE 10]

7

In happy copulation; if in evening mild. wearied with work:

Sit on a bank and draw the pleasures of this free born joy.

 The moment of desire! the moment of desire! The virgin

That pines for man; shall awaken her womb to enormous joys

In the secret shadows of her chamber; the youth shut up from 5

The lustful joy, shall forget to generate. & create an amorous image

In the shadows of his curtains and in the folds of his silent pillow.

Are not these the places of religion? the rewards of continence!

The self enjoyings of self denial? Why dost thou seek religion?

Is it because acts are not lovely, that thou seekest solitude, 10

Where the horrible darkness is impressed with reflections of desire.

Father of Jealousy, be thou accursed from the earth!

Why hast thou taught my Theotormon this accursed thing?

Till beauty fades from off my shoulders darken'd and cast out,

A solitary shadow wailing on the margin of non-entity. 15

I cry, Love! Love! Love! happy happy Love! free as the mountain wind!

Can that be Love, that drinks another as a sponge drinks water?

That clouds with jealousy his nights, with weepings all the day:

To spin a web of age around him. grey and hoary! dark!

Till his eyes sicken at the fruit that hangs before his sight. 20

Such is self-love that envies all! a creeping skeleton

With lamplike eyes watching around the frozen marriage bed.

But silken nets and traps of adamant will Oothoon spread,

And catch for thee girls of mild silver, or of furious gold;

I'll lie beside thee on a bank & view their wanton play 25

In lovely copulation bliss on bliss with Theotormon;

Red as the rosy morning, lustful as the first born beam,

Oothoon shall view his dear delight, nor e'er with jealous cloud

Come in the heaven of generous love; nor selfish blightings bring.

Does the sun walk in glorious raiment, on the secret floor 30

[PLATE 11]

 (drop

Where the cold miser spreads his gold! or does the bright cloud

On his stone threshold? does his eye behold the beam that brings

Expansion to the eye of pity? or will he bind himself

Beside the ox to thy hard furrow? does not that mild beam blot

The bat, the owl, the glowing tyger, and the king of night. 5

The sea fowl takes the wintry blast. for a cov'ring to her limbs:

And the wild snake, the pestilence to adorn him with gems & gold.

And trees. & birds. & beasts. & men. behold their eternal joy.

Arise you little glancing wings. and sing your infant joy!

Arise and drink your bliss. for every thing that lives is holy! 10

Thus every morning wails Oothoon. but Theotormon sits

Upon the margind ocean conversing with shadows dire.

The Daughters of Albion hear her woes. & eccho back her sighs.

The End

THE HUNTINGTON COPY:

Bibliographic and Textual Notes

T HE FULL-SIZE color reproduction of *Visions of the Daughters of Albion* in this volume is based on the copy in the Huntington Library, designated as copy E in the standard bibliography of Blake's writings (G. E. Bentley Jr., *Blake Books* [Oxford: Clarendon Press, 1977]). It was printed in 1793 in light yellow ochre ink on sheets of wove paper; the leaf bearing plates 2 and 3 shows a "J WHATMAN" watermark. At least ten other copies were produced in the same year, and possibly in the same printing session, in yellow ochre or green ink. The plates range in size between 14.3 × 11.2 cm and 17.1 × 13 cm. Plate 1, the frontispiece, was printed on the verso of the first leaf and was bound to face the title page; plates 2–11 were printed on both recto and verso. This format has been preserved in the present reproduction. The graphic method Blake used to produce *Visions of the Daughters of Albion* and his other illuminated books is described in the Commentary.

Ralph Brocklebank is the first recorded owner of the Huntington copy. He probably had the leaves trimmed to their present size, 24.3 × 21 cm, and bound in full red morocco; his bookplate is on the inside front cover. The book was acquired from Brocklebank's collection at a Christie's auction in London (10 July 1922, lot 69) by the dealer Frank T. Sabin for £185. Another dealer, Maggs Bros. of London, offered the book in their sale catalogue 428 of 1922 (lot 184; £315). Henry E. Huntington purchased the book through the dealer Thomas J. Gannon for $1750 in 1923, and the volume has been in the Huntington Library since then. *Visions* was disbound in 1983 and the leaves preserved in a paper folder. The former binding has been retained by the Library.

~

The typographic transcription of the poem is based on the Huntington copy. No attempt has been made to collate it systematically with all other copies, but a few comparisons have been included in the textual notes, below. Blake's idiosyncratic punctuation (which would seem to register spoken pauses and emotional emphases more than the logic of syntax and grammar), lineation, and spelling have been retained. Punctuation marks with "tails," such as commas and semicolons, lose those tails in some copies because of slight and random variations in inking. The Huntington copy is notable in this regard, for many marks that print as commas or semicolons in other copies appear here as periods and colons.

Although *Visions of the Daughters of Albion* is a printed text, it is autographic, like a manuscript, and shows the continuous variations of Blake's handwriting. Thus, typographic editions of Blake's illuminated texts are translations into a very different and far more regularized medium. The transcribed text is meant as an aid to understanding and reference; in no sense is it a replacement for the reproduction in this volume, much less for the original.

In the textual notes below, the numbers refer to plate and line as given in the transcription of the poem in the preceding section.

3:6 The terminal punctuation hovers between a colon and a semicolon. The mark is more clearly a semicolon in other copies.

4:5 Small, arching lines just below the upper strokes forming the *M* of "Marygold" indicate that Blake first wrote a lowercase *m* and then converted it to a capital. The upper strokes of the lowercase letter are barely visible in the Huntington copy but are quite clear in copies I (Yale Center for British Art) and J (Library of Congress).

4:8, 5:2, 6:17, 11:1 In each of these four lines, the copperplate was insufficiently wide to accommodate the full line of verse. Thus Blake was forced to write the last word of each line either above or below it.

5:10 There would appear to be a completely displaced colon below and to the right of the end of the line. Nothing like it appears in other copies, and these two dots, one above the other, are probably just some accidental inking of a recessed area on the plate, unique to this copy.

5:24 The terminal comma is very lightly inked in this copy and only barely visible. It was etched on the plate and is more clearly inked and printed in most other copies.

5:34, 37 The periods after "was" (line 34) and "hears" (line 37) do not appear in other copies and may be the result of accidental inking of etched areas. Further, they seem particularly interruptive and would appear to violate the syntax and grammar of these lines. I have recorded them here because they are clearly visible in this copy.

7:7 The word "present," which was etched on the copperplate, was changed to "prevent" with pen and ink on the impression of plate 7 in copy G (Houghton Library, Harvard University). This revision makes no sense in context, but it may have been part of an unrealized intention to change the line to "Comforts to prevent sorrow and a night of pain."

7:13 The upper dot of the terminal punctuation is very faint in this copy, but it is clearly printed in most others.

7:18 Blake etched a question mark at the end of this line, but it prints clearly only in copy P (Fitzwilliam Museum).

8:6 The punctuation mark following "infinite" appears to be a vertical line above a comma. There being no such mark in standard typographic punctuation, it has been recorded here as an exclamation point.

10 The etched plate number ("7") upper right is painted over in this copy but is still visible.

11:1 The mark after "gold," printed here as an exclamation point, may be a question mark. The upper stroke, more clearly printed in several other copies, has a slight bend in it.

Commentary

LIST OF ILLUSTRATIONS FROM BLAKE'S NOTEBOOK

BLAKE FIRST sketched several of the designs and individual figures for *Visions of the Daughters of Albion* in the Notebook he inherited from his brother Robert in 1787 and used for many years for both pictorial and verbal compositions. This Notebook, containing fifty-eight leaves measuring 20 × 15.5 cm, has been held in the British Library, Department of Manuscripts, since 1957. All the drawings related to *Visions of the Daughters of Albion* were executed in pencil. They are reproduced and discussed in the Commentary section of this volume, immediately following this list of illustrations. In several instances these drawings were not specifically composed in anticipation of *Visions*; rather, Blake reused in *Visions* motifs first executed as part of some earlier project.

The texts on the Notebook pages reproduced here are not related to the drawings or to the text of *Visions*—with one exception (figure 2)—and were written by Blake at least fifteen years later. On pages 28, 32, 50, and 92 (figures 5–8), these later texts in pen and ink obscure part or all of the drawings; on page 30 (figure 2), the over-writing covers the caption of the drawing. In order to make these drawings and one relevant text visible, we have digitized photographs supplied by the British Library and digitally manipulated the images to remove the obscuring words. The erasures on these pages are specified in the list below. The pale pencil lines in most of the drawings have been darkened to make the motifs more visible.

I am grateful to the Department of Manuscripts of the British Library for photographs of Blake's Notebook and for permission to manipulate the images digitally and reproduce them here. I also wish to thank Manuel Flores and John Sullivan of the Huntington Imaging Lab for their expert work in preparing all the illustrations. Susan Green's editorial management has made a major contribution to this volume.

FIGURE 1, page 29. Blake's Notebook, page 74, with motifs related to plates 1, 2, 7, 10, and 11 of *Visions of the Daughters of Albion*.

FIGURE 2, page 31. Blake's Notebook, page 30, related to plate 2. Three lines of unrelated text, written c. 1808–11, have been removed to reveal the caption below the design.

FIGURE 3, page 32. Blake's Notebook, page 72, related to plate 2. A large rectangle was cut from the upper left

portion of this leaf at an unknown time and for unknown reasons.

FIGURE 4, page 33. Blake's Notebook, page 81, related to plate 2.

FIGURE 5, page 39. Blake's Notebook, page 28, related to plate 3. Three lines of unrelated text, written c. 1808–11, have been removed from the upper portion of the design.

FIGURE 6, page 47. Blake's Notebook, page 32, preliminary drawing for plate 6. Ten unrelated words, written c. 1808–11, have been removed from the tips of the eagle's wings.

FIGURE 7, page 52. Blake's Notebook, page 50, related to plate 7. Most of the words in five lines of unrelated text, written c. 1818, have been removed from the drawing above the central design (the latter unrelated to *Visions*).

FIGURE 8, page 53. Blake's Notebook, page 92, preliminary drawing for plate 7. Most of the words in eleven lines of unrelated text, written c. 1810, have been removed from the drawing.

FIGURE 9, page 62. Blake's Notebook, page 78, preliminary drawing for plate 11.

COMMENTARY

"Never...was a man so literally the author of his own book." Alexander Gilchrist's words, written in 1863, remain true to this day for William Blake's most innovative productions, his "illuminated books."[1] Among these rare works is the Huntington Library's copy of *Visions of the Daughters of Albion*—written, illustrated, and first printed by Blake in 1793 and reproduced in color in this volume. An appreciation of its artistry will be assisted by a brief consideration of Blake's background as a printmaker, his invention of the unique method he used to etch his texts and designs, and his development of illuminated printing in the late 1780s and early 1790s.

When, in 1772, it came time to establish Blake in a profession, his father apprenticed the fourteen-year-old boy to the engraver James Basire.[2] Under his master's direction, Blake learned and labored for the traditional seven years in preparation for a career devoted mainly to etching and engraving on copperplates images drawn by other artists. Blake practiced this craft throughout his adult life, but his ambitions exceeded its artistic conventions and social boundaries. Shortly after his release from apprenticeship in 1779, Blake enrolled in classes offered by the Royal Academy, London, to train himself as an original artist. He exhibited a watercolor, *The Death of Earl Goodwin*, at the R. A. in the next year; other pictures based on historical and biblical subjects followed in the 1784 and 1785 exhibitions. During this same period, Blake made known to a small circle of friends the poems he had been writing since childhood. With their financial assistance, Blake's *Poetical Sketches* was privately published in conventional letterpress in 1783. His efforts as both artist and poet went largely unnoticed; by the late 1780s, Blake and his wife, Catherine, continued to rely on ordinary reproductive engraving for their livelihood. In about 1788, Blake composed a narrative poem, *Tiriel*, and a series of illustrations to accompany it, but these were never published in Blake's lifetime. London's booksellers and patrons in the arts seem to have provided little assistance in Blake's attempts to establish himself as both artist and poet.

Blake was exceptionally close to his youngest brother, Robert, who was also set on a career in the arts. Robert died early in 1787; William was grief stricken, but the youth remained a living presence to him. According to John Thomas Smith, author of an early biography of

Blake, Robert inspired the new mode of etching and printing used in the illuminated books. Smith's seminal account is worth quoting in full:

> Blake, after deeply perplexing himself as to the mode of accomplishing the publication of his illustrated songs, without their being subject to the expense of letter-press, his brother Robert stood before him in one of his visionary imaginations, and so decidedly directed him in the way in which he ought to proceed, that he immediately followed his advice, by writing his poetry, and drawing his marginal subjects of embellishments in outline upon the copper-plate with an impervious liquid, and then eating the plain parts or lights away with aquafortis considerably below them, so that the outlines were left as a stereotype. The plates in this state were then printed in any tint that he wished, to enable him or Mrs. Blake to colour the marginal figures up by hand in imitation of drawings.[3]

The basic features of Smith's description of what is now known as "relief etching" have stood the test of modern scholarly scrutiny and graphic experimentation.[4]

Whatever the spiritual origins of the technique, its invention would not have been possible without Blake's training as a commercial engraver. Conventional (or "intaglio") graphics required the craftsman to make small incisions in the metal plate—lines or dots—with either a tool (engraving), or with acid (etching), or with a combination of the two (the "mixed method" widely employed in Blake's time). For etching, the plate was entirely covered with a "stopping-out" varnish resistant to acid. The craftsman would then use a needle to scratch into the varnish and expose the metal wherever required to create the lines and dots delineating a pictorial image or words. Acid would then be poured on to the plate to eat into its exposed portions while the rest of the plate's surface was protected by the varnish. To print the design or text, the varnish was removed with solvent and the plate smeared with ink. The printer—usually a craftsman different from the engraver—wiped the plate's surface free of ink but made certain that it remained in the incisions delineating the image. Finally, the plate was printed with heavy pressure in a rolling press specifically designed for the task.

Blake's invention was in several respects the reverse of these conventional procedures. Instead of covering the entire plate with varnish and then removing some of it (a negative process), Blake's technique was positive and compositional. Like an author writing with a pen on paper, or an artist drawing on paper or painting on canvas, Blake drew his designs and text on the copper with heated varnish that would solidify on contact with the cool metal. Printing a copperplate, just as with printing standing type, reverses right and left, as in a mirror; thus, Blake had to write his words from right to left. This may seem a considerable difficulty to most of us today, but it was only a minor challenge for a skilled engraver, trained to execute images and their attendant inscriptions in reverse.

At any point prior to the application of acid, relief etching permits easy correction. The artist can simply remove varnish already painted on the plate or add more. Even in his earliest relief plates, Blake took advantage of this property of his medium by scraping lines in varnished areas to expose the metal. As a result, part of the image—usually hatching and crosshatching patterns to model forms—could be defined by the white of the paper against a dark (printed) background. Entire designs or even text could be executed using this technique, now generally known as "white-line etching." After the application of acid, relief areas could still be cut away with a sharp tool, but nothing significant could be added.

To etch his relief plates, Blake used one of the standard methods for accomplishing this task by constructing a low wall of wax around the plate and pouring acid into this shallow container. The exposed metal was eaten away, leaving the design and text in relief. Although Smith's description of the process suggests that the etching was deep, modern experiments, as well as the one extant fragment from one of Blake's copperplates etched in

relief, [5] suggest that the etching could be quite shallow. After removal of the wax border and varnish with a solvent, the plate was ready for inking and printing. Blake worked before the invention of inking rollers, and thus he must have employed a dabber, similar to the inking balls used by typographic printers, to ink the relief surfaces of his plates. He probably used the sorts of intaglio inks familiar to his profession; these were more viscous than relief inks, used for type and woodcuts, and created the fine reticulated patterns so distinctive of impressions pulled by Blake and his wife. They often used colored inks, but rarely more than one color on any single plate. The inked plates were positioned in the bed of the rolling press Blake owned and the paper positioned on top of the plates. By placing two plates in the press, as seems to have been customary in his earlier printing sessions, Blake and his wife could cut in half the number of "pulls" through the press required to produce any given number of impressions. After the ink dried, Blake frequently printed a second plate on the backs of his individual sheets of paper, thus creating a text printed recto and verso, as in almost all conventional books. Except for its frontispiece, printed on one side of the paper only, the Huntington copy of *Visions of the Daughters of Albion* was printed on both sides of the leaves, just as it is reproduced here.

The Blakes printed multiple impressions of each plate for later assembly into individual copies. Hand coloring appears to have been executed with watercolors before the collation of individual impressions into copies. The basic unit of production was the printing and coloring session, not the individual copy. For the first few years of illuminated-book production, Blake and his wife used delicate watercolors. In 1794, Blake began to color print his relief plates in a thick glue-based medium that created dense, heavily reticulated effects that required further work with brush and pen to sharpen outlines and define motifs. After the turn of the nineteenth century, Blake returned to hand coloring without color printing, but in a far more elaborate style than what we find in the early books. Mrs. Blake was probably responsible for the final

stage of production, the binding of copies in simple paper wrappers.

The advantages of Blake's graphic invention were several. Even if the same person executes all stages of production, intaglio etching and engraving were reproductive media in the sense that a detailed drawing had to be prepared and either copied or mechanically transferred onto the copperplate. Relief etching was autographic, for it directly recorded the artist's positive gestures with brush or stylus executed on the plate. No detailed preliminary drawings, scaled to the size of the plates, were necessary; indeed, none is known for any of Blake's relief etchings. In some cases, he sketched a composition for one of his illuminated books in his Notebook, now in the British Library, London. These are all, right and left, the reverse of the illuminated prints, indicating that he recomposed the designs—usually with modifications—directly on the copperplate, which then reversed the image in the printing process. The Notebook is unusually rich in sketches related to *Visions of the Daughters of Albion*; all of these are reproduced and discussed below (see the "List of Illustrations from Blake's Notebook," above).

Since Blake was his own printer, he did not have to prepare completely accurate and formatted "fair copies" of his texts.[6] They could evolve, both in details of verbal content and in elements of design, such as the number of lines per plate, while the words were written in varnish on the copper, seriatim. The final stages of inking and printing the surface of the plate were much faster than in conventional intaglio methods, as described earlier. Although the terms may seem self-contradictory, it is fair to call Blake's illuminated prints composites of "printed drawings" and "printed manuscripts." Blake thereby joined in mutual support his skills as a trained engraver with his efforts as an original artist and poet. Invention and execution, separated in reproductive graphics, were fruitfully intermingled.

Blake may have tried to sell, or at least display, his books at the shop of Joseph Johnson, a bookseller and publisher for whom he worked as a commercial book

illustrator and engraver. But there are no records of initial sales through dealers; the vast majority of copies must have been sold directly to individual customers. By keeping all stages of production and even distribution in their own hands, Blake and his wife avoided reliance on printers and booksellers and could maintain an unusual degree of control over the illuminated books. Blake must have originally hoped for many more sales than he ever achieved, but even his early print runs were quite small compared to commercially produced books of the period. He continued, at various times throughout his life, to print new copies of his early illuminated books and, between 1804 and 1820, produced two illuminated epics, *Milton a Poem* in fifty plates and *Jerusalem* in one hundred plates. The most popular books were *Songs of Innocence* (1789), with twenty-six copies now extant, and the combined *Songs of Innocence and of Experience* (1794), now known in twenty-eight copies. There are presently sixteen known copies of *Visions of the Daughters of Albion*, plus two previously recorded but untraced copies and a proof set of six out of the total of eleven plates.

Blake may have first thought of his invention as a way to create multiple facsimiles of drawings. "The Approach of Doom," a composite of relief and white-line etching without text, may be one of Blake's earliest experiments. Appropriately, given Smith's story about the inspiration for relief etching quoted earlier, "The Approach of Doom" is based on a drawing by Robert Blake. Combinations of designs and texts were soon to follow, first with a sequence of small emblem plates with accompanying aphorisms entitled *All Religions are One* (c. 1788); the only known copy of this work is in the Huntington Library. As his title indicates, Blake claims that all religious beliefs, however various, have a common origin in the "Poetic Genius" (E1), the godlike spirit within all people. Typically, Blake seeks for an underlying unity, even though his texts appear to be under constant threat of fragmentation and dispersal. This is because Blake

strives for a paradoxically non-homogenous unity that does not violate his sense of individuality constituted by variety and does not submit to what he saw as the bondage of abstract generalizations. In *All Religions are One*, the essence of the human is defined in such terms: "As all men are alike in outward form, So (and with the same infinite variety) all are alike in the Poetic Genius" (E1).

A similar series of plates, *There is No Natural Religion*, etched in the same year, further explores the relationship between perceptions based on the senses, including the arguments for "natural" religion (or deism) that Blake criticizes, and spiritual perceptions, such as those underlying what were then called "revealed" religions, such as Christianity. Following a series of propositions that summarize rationalist doctrines Blake associated with the writings of Francis Bacon, Isaac Newton, and John Locke, Blake offers a second series directly refuting the first group. In Blake's view, knowledge limited to what the "organs of sense" (E2) can teach would limit us to knowing only the fallen world of nature. But humans experience desires—and hence, in the widest sense, have perceptions—that reach beyond such limits. As we shall see, the relationship between these two modes of perceiving and knowing, and a celebration of "infinite variety," will play significant roles in *Visions of the Daughters of Albion*.

Songs of Innocence (1789) is Blake's first book of illuminated poetry. Working within, yet reaching beyond, the conventions of children's verse, Blake imagines a world where human consciousness has yet to descend into the multiple divisions of adulthood—spirit and nature, mind and body, self and other. But these brief lyrics are not divorced from the struggles of innocence to preserve its vision in the face of hardship. "The Chimney Sweeper" (E10) dramatizes, from a child's innocent perspective, the exploitation of young boys forced into the hazards of cleaning London's soot-filled chimneys. We find in such poems Blake's typical attempt to place contemporary social issues within a context of what he believed to be universal and eternal mental states. The

companion volume, *Songs of Experience*, did not appear until 1794; the two works were united in the same year under a general title, *Songs of Innocence and of Experience*.

Two linked poems in *Innocence*, later transferred to *Experience*, follow the adventures of a young girl as she wanders into the forest of experience. Her parents are fearful in "The Little Girl Lost," but the "beasts of prey" (E20) prove protective, as though the innocent child had the projective power of converting the external world to her own condition. "The Little Girl Found" follows the parents as they search through a wilderness made fearful by their own fears, but they are at last converted to the vision of innocence and the "desart wild" (E21) becomes a demi-Eden. These two poems would appear to be the antecedent to Blake's next illuminated work, *The Book of Thel*, also written in 1789 but possibly not completed until early 1790. Once again Blake centers his story on a young female as she confronts a spiritualized and potentially transformative world of natural creatures. For the first time in an illuminated book, Blake abandoned his earlier genres of aphorism and lyric in favor of verse narrative written in iambic septenaries of fourteen syllables, the form he would use in most of his later poems, including *Visions of the Daughters of Albion*. Also like *Visions*, *The Book of Thel* deploys the interrogative as one of its principal rhetorical modes. Thel seeks answers to questions about the meaning of life—and particularly about its transience—and receives soothing, but not necessarily convincing, answers from a lily, a cloud, and a "Clod of Clay" (E5). The gentle pastoral mood turns to the horrific sublime at the end of the poem as Thel comes upon her own grave and hears a voice, the contrary but revelatory echo of her own, redolent with fears less of death than of sexuality. Visions of innocence darken into torments physical and psychic.

Blake's next illuminated book, *The Marriage of Heaven and Hell* (1790), stands out as an explosive performance even in the context of Blake's heterodox writings. Its complexities are too vast to summarize here, but a few of the book's characteristics are harbingers of what we will find in *Visions of the Daughters of Albion*. As in Milton's *Paradise Lost*, many of the best lines are given to the devil in a dramatic displacement of the author's own voice that immediately raises difficult questions about the relationship between what the devil says and what Blake believes. We can assume, however, that Blake was at least sympathetic with the forceful declarations he creates for his devilish persona:

1 Man has no Body distinct from his Soul for that calld Body is a portion of Soul discernd by the Five Senses. the chief inlets of Soul in this age

2. Energy is the only life and is from the Body and Reason is the bound or outward circumference of Energy.

3 Energy is Eternal Delight (E34)

The "Proverbs of Hell" follow in a similar vein and lead to an apocalyptic conversion of the "whole creation" through "an improvement of sensual enjoyment" (E39). *The Marriage of Heaven and Hell* concludes with "A Song of Liberty" calling for the overthrow of all tyrannies, secular and religious, and the release of all imprisoned energies, "For every thing that lives is Holy" (E45). Blake's work is now infused with the spirit of the French Revolution, which began in the previous year and had yet to descend from liberty into terror.

In the same year as *Visions of the Daughters of Albion*, Blake wrote and etched *America a Prophecy* as the first in a series of "continent" books that trace the progress of revolution and its attendant conflicts throughout the world. This context of Blake's own thought and expression reminds us not to overlook the political dimensions of *Visions*, even though it concentrates on the plight of a single figure. As in so many of Blake's writings, the poem subverts the useful—but arguably false—dichotomies between the personal and the political, the local and the cosmic, much as the devil in *The Marriage of Heaven and Hell* denies the distinction between body and soul.

Accordingly, Blake's texts are often amenable to modern critical perspectives that also question binary structures, particularly when the social enactment of such structures tends to privilege one half of the interlinked pair over the other, be it master over servant, male over female, or mind over body.

~

Further complexities unfold because of Blake's most commonly used rhetorical strategies. It is often useful (albeit rather mechanical) to analyze figures of speech (metaphor, simile, metonymy, etc.) into a "vehicle"—the image explicitly named in a poem (for example, a rose)—and a "tenor"—the meaning or referent of the image (for example, love). Texts that are reasonably straightforward and univalent in their deployment of such structures are often categorized as allegories (or even "simple allegories") of the sort we find in the medieval play, *Everyman*, and John Bunyan's immensely popular *Pilgrim's Progress* (part 1 published 1678, part 2 published 1684). Texts that are less rigid, and that seem to marshal their images in service of multiple tenors, are often categorized as symbolic (or even "vaguely symbolic"), as in French symbolist poetry of the nineteenth century and its twentieth-century inheritors. Such texts rely on emotional suggestion more than traditional emblematic equations or one-to-one correspondences defined (implicitly or explicitly) by the text itself.[7] Most of Blake's poetry, including *Visions of the Daughters of Albion*, would seem to traverse this spectrum, sometimes giving at least the appearance of allegory and at other times displaying extravagantly polyvalent images that elude rational explanation. Even the characters of Blake's poetry create problems in generic definition. Are they (and their odd-sounding names) representatives of psychic categories, as in allegory, or are they complex and "realistic" personalities of the sort we encounter in nineteenth-century novels? As Blake wrote, in a decidedly intemperate mood, to his erstwhile patron Dr. John Trusler in 1799, "That which can be made Explicit to the Idiot is not worth my care" (E702).

Much recent criticism of *Visions of the Daughters of Albion* has concentrated on an investigation of the precursor texts that influenced its plot, imagery, and themes. The poems of Erasmus Darwin (Charles Darwin's grandfather), John Gabriel Stedman's *Narrative, of a Five Years' Expedition, Against the Revolted Negroes of Surinam* (1796), and Mary Wollstonecraft's *A Vindication of the Rights of Woman* (1792) have received particular attention as ways of contextualizing, and thereby explaining, Blake's work. That he knew these texts is certain: Blake engraved illustrations for the 1791 edition of Darwin's versified excursion into the lives of plants, *The Botanic Garden*; he knew Stedman and began in 1791 to engrave plates for Stedman's often horrific tale of slavery in South America; and he both designed and engraved the illustrations for the 1791 edition of Wollstonecraft's *Original Stories from Real Life* and very probably knew her as a member of the Joseph Johnson circle. Wollstonecraft's *Vindication* is one of the foundational texts for modern feminist theory and thus offers an historical connection between Blake's illuminated books and current reflections on gender and culture.

The ways of reading Blake's texts exemplified by the foregoing paragraphs have their inherent dangers. A general discussion of his rhetorical strategies can become a way of avoiding the immediate complexities of any given exemplar of those strategies. Similarly, excursions into historical and philosophical contexts can all too easily treat a poem as an anonymous assemblage of other texts. In both cases, we are led away from the texture of Blake's poetry, *as* poetry, and never grapple with basic questions about what is happening in his narrative, who is doing what to whom, and what the characters' speeches mean (or how they fail to mean).

To counter these tendencies, I propose a rather old-fashioned solution. Let us work our way through *Visions of the Daughters of Albion* from start to finish, line by line when necessary. To be even more specific, this will be a reading of the Huntington's copy of *Visions*, not a generalized interpretation of all copies or of some hypothetical "standard" copy.[8] As individual passages raise important

historical issues, or when Blake's words echo earlier texts, we will take brief excursions into such contexts when they assist understanding. The designs, equal partners in Blake's composite art, and bibliographical features, such as page layout and calligraphic styles, will also receive attention in the following attempt to recreate a fully integrated reading/viewing experience of the Huntington Library's *Visions of the Daughters of Albion*.

First Opening:
Frontispiece and Title Page

The placement of the frontispiece so that it faces the title page follows the conventions of Blake's time and ours. But in *Visions*, this format produces an overwhelming visual impact when we first open the book. A frontispiece portrait of the author, or a design picturing a major scene in the text to follow, was conventional in Blake's day, but title-page illustrations were generally limited to a vignette discrete from the title lettering. The title page of *Visions*, with its complex design, serves almost as a second frontispiece. Blake's etching medium for combining pictures and words allowed a much fuller integration of the two than what we find in conventional books, circumscribed by the physical differences between relief type and intaglio graphics.[9] The title words seem to float over the design as a textual overlay on the world represented by the design, while the sinuous shapes of the letters accord with the forms of clouds and human bodies surrounding them. The motto or epigraph and the imprint float on the waves below. Our field of vision is so dominated by the pictorial that we may have to do a bit of searching to discover the verbal information we normally expect from a title page.

After a quick survey of the title page, the habit of reading/viewing left to right will probably lead us back to the frontispiece. There we meet three figures. With his open mouth and staring eye, his hair standing on end, the male lower left appears frightened by some unseen presence off-stage to the left. Is he having one of the "visions" announced by the title? The shackle encircling his left ankle is presumably chained to the large link or eyebolt below; the link of another chain extends upward toward his back. His legs are pulled up to his chest and his left arm is pulled behind his back; perhaps both his arms are chained. If so, then we are led to assume the same for the female, whose legs are more gracefully disposed in a kneeling posture but whose right arm is also pinned back. Her nude and sensuous body is fully displayed in profile, but her downcast head and lowered eyelids suggest sadness. The couple seem bound back to back in postures expressive of male terror and female sorrow. The musculature of the third figure, above and to the right, indicates a male. His body language—a fetal position, with his head lowered and his arms wrapped around it—bespeaks self-enclosed despair. Moving left to right from figure to figure, we move as well from heightened (although hardly happy) visual perception, to eyes half shut and focused only on the ground (if seeing at all), to an utter absence of sensory connection with the world.

The figures are displayed like a *tableau vivant* beneath a proscenium arch formed by the mouth of a cave. The landscape is elemental—rocks, sand, water, air—with only a bit of vegetation dangling from the top of the cave. The setting, on the margin between sea and land, has been associated with the conception of "marginality" in current cultural studies, that position (intellectual, racial, linguistic) between categories that foregrounds both their differences and the possibility of transgressing those differences. Taking a more historical approach, we can also associate Blake's setting with other late-eighteenth-century seaside pictures, usually evocative of a contemplative but troubled state of mind. Blake's friend Thomas Stothard (1755–1834), one of England's most popular and prolific book illustrators, drew a number of such scenes, often including a woman waiting anxiously for the return of her sailor-lover. One example, engraved by Blake for Joseph Ritson's *Select Collection of English Songs* (1783), resembles the rocky cliff, sea, and sorrow of plate 7 in *Visions*. Several paintings by Joseph Wright of Derby (1737–97) show pensive figures seated within a cave's

mouth, the sea beyond. All of these compositions evoke sublimity in one of its gentler, more pathetic moods. Blake's female sustains the element of pathos, but his bound and frightened male adds a note of terror.

Since the sea and sky lie beyond the figures, we as the observers of the scene are placed deeper within the cave and look out from its interior, a position that calls to mind Blake's complaint that "man has closed himself up, till he sees all things thro' narrow chinks of his cavern" (*The Marriage of Heaven and Hell*, E39). This emphasis on perception is also suggested by the sun, seen through clouds that resemble the outline of an eye socket. Indeed, some viewers have found in the overall composition a skull, seen in profile facing left, with the sun as the eye, the roof and right wall of the cave as the top and back of the skull, and the figures disposed in such a way as to suggest a jawline. This configuration continues the skull/ cave metaphor of the passage from *The Marriage* and places the characters within the head—perhaps the viewer's head—and thereby suggests that they are personifications of mental faculties. Inner and outer worlds intermingle in intriguing ways as the design plays upon our powers of perception (cave or skull or both?) while addressing the senses as a major theme in its iconography.

The posture of the right-most figure on the frontispiece recalls the pencil sketch top left on page 74 of Blake's Notebook (figure 1). The leg and head positions are especially similar, but the arms have been reconfigured from their lowered and partly hidden position in the sketch to encircle the man's head in the print. The small figures on page 74, excluding the portraits, would seem to be part of a group. Some suggest letter forms, such as a *Y* (top left), a *V*, and perhaps a *D* (the soaring figure just below), and an *O* (bottom left). Blake may have been sketching an anthropomorphic alphabet. Thus, it seems likely that the figure top left was not specifically executed as a preliminary for *Visions*. Rather, Blake returned to his Notebook, at least in memory, and both borrowed and modified the figure for his illuminated book. He treated the Notebook as both a place for

making new preliminary sketches and a pictorial dictionary from which he could glean previously executed motifs.

The yellow ochre color of the printing ink used on all plates in the Huntington copy is appropriate for the earth-bound setting of the frontispiece, but the semi-transparent washes added by hand may seem a little tame for such a design. Blake colored all copies of *Visions* produced in the first printing and coloring session in a similar palette; indeed, he tended to use the same basic range of colors and styles across several different illuminated books in any given period. Thus, we find that early copies of *Songs of Innocence* and *The Book of Thel* display hand coloring basically similar to what we see in the Huntington *Visions*. In 1794, Blake color printed and richly hand colored at least two copies of *Visions*. Their densely reticulated surfaces and deep tones underscore the brooding sublimity of the designs.

The frontispiece presents a unified composition dominated by three large figures. In contrast, the title page offers a complex arrangement of small figures that share the same pictorial seascape and sky but tend to separate into discrete groupings. The eye is led first to the figure soaring through air and flames with arms wrapped around his shoulders in yet another self-enclosing posture. His giant wings underline the last word of the title, while his facial features express both torment and advanced age. Blake may be playing upon traditional representations of the Holy Ghost soaring above the ocean or the dove sent over the waters by Noah (Genesis 8). Here the beneficent bird is transformed into (or replaced by) the satanic pursuer of the youthful female striding between waves. Her energetic, contrapposto aspect contrasts with the postures displayed on the frontispiece, but the spread fingers of her raised hands suggest fear rather than freedom. To the left, and seemingly about to be cut by the wing just behind, is a circle of three women and loops of trailing drapery. They soar or dance with energetic, perhaps sexual, abandon. A fourth figure descends toward the ring. A rainbow, perhaps another allusion to the story

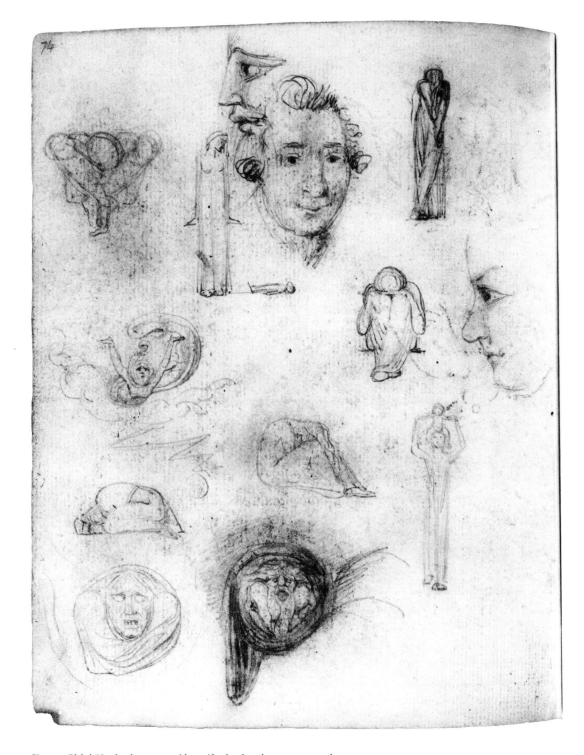

Figure 1. Blake's Notebook, page 74, with motifs related to plates 1, 2, 7, 10, and 11

of Noah, extends through these figures and arcs toward the top right corner of the design. This motif is indicated on the plate only by a few etched lines that would hardly be noticed without the colorful hand tinting.

Three prominent figures above the rainbow on the left lie on cloud outlines in postures of sorrow or exhaustion. Another, bent over (in despair?) just above the *i* of "Albion," recalls the contracted figures of the frontispiece. Upper right, a long-haired male with crossed legs leans to the right, arms and fingers extended as though he is casting down the slanting lines of rain below his cloudy seat. Two huddled forms, lower right, seem inundated by the storm. These shapes are not easily identified, for they seem to hover somewhere between the geologic and the human. Are they distant cliffs drenched with water, or figures with heads bent low between prominent shoulders and long hair cascading with the rain? Once we consider the latter possibility, it is difficult to prevent our eyes from seeing the shapes in anthropomorphic terms.

~

The title-page design is rich with borrowings from the paintings and drawings of Henry Fuseli (1741–1825). Blake implicitly acknowledged his indebtedness to his friend's designs during the early 1790s when he stated, in a letter of September 1800, that "when [the neoclassical sculptor John] Flaxman was taken to Italy," 1787 to 1794, "Fuseli was giv'n to me for a season" (E707). The winged demon was clearly influenced by the rain god pictured by Fuseli in "Fertilization of Egypt," an illustration for Darwin's *Botanic Garden* engraved by Blake in 1791. Blake may have known that Fuseli's figure was itself based on a relief of Jupiter Pluvius from the column of Marcus Aurelius, a source of some relevance to Blake's design since that deity was notorious in several classical myths as a pursuer (indeed, a rapist) of women.[10] In this instance, the pictorial source directs our attention to one possible iconographic "reading" of Blake's fleeing female and threatening male. Other figures on the title page, displayed with a mixture of torment, sexual abandon,

and postcoital *tristesse*, would remind a late-eighteenth-century British audience of many works by Fuseli, although only one further motif can be traced to a specific design. The ring of dancers may have been prompted by a very similar group in Fuseli's *The Shepherd's Dream*, first executed as a drawing in 1785 and used as the basis for one of his major works in oil in 1793. Fuseli's design is in turn based on a passage in Milton's *Paradise Lost*; perhaps the exuberant joy expressed by Blake's dancers is also about to be lost.

A more immediate source for the ring of dancers can be found among a series of sixty-four small drawings Blake sketched within "frames" in his Notebook (figure 2). These were probably composed as preliminaries for a series of engraved emblems, but Blake used only seventeen of them in *For Children: The Gates of Paradise* (1793). The remainder provided a storehouse of images that could be used for other projects. The sketch of the dancers includes a caption, partly covered by later ink writing that has been digitally removed in figure 2 to reveal the following lines:

> A fairy vision of some gay
> creatures of the element who
> in the colours of the rainbow live
> > Milton

This quotation from Milton's *Comus*, lines 298–300, underscores the joyful tenor of the pictorial motif and may also have suggested the rainbow pictured on the title page. Both Milton's masque and Blake's *Visions* center upon a female virgin in peril, thereby providing a further, thematic link among these interrelated designs and texts.

Blake used other Notebook drawings for figures on the *Visions* title page. The female running across the waves is taken from another emblem sketch (figure 3). This shows two motifs not included in the relief etching, a rising or setting sun on the horizon on the left and the odd forms, perhaps dangling legs, upper right. Unfortunately, a large rectangle has been cut from this Notebook leaf, as figure 3 reveals. The figure upper right on the title page, legs crossed and arms extended to the

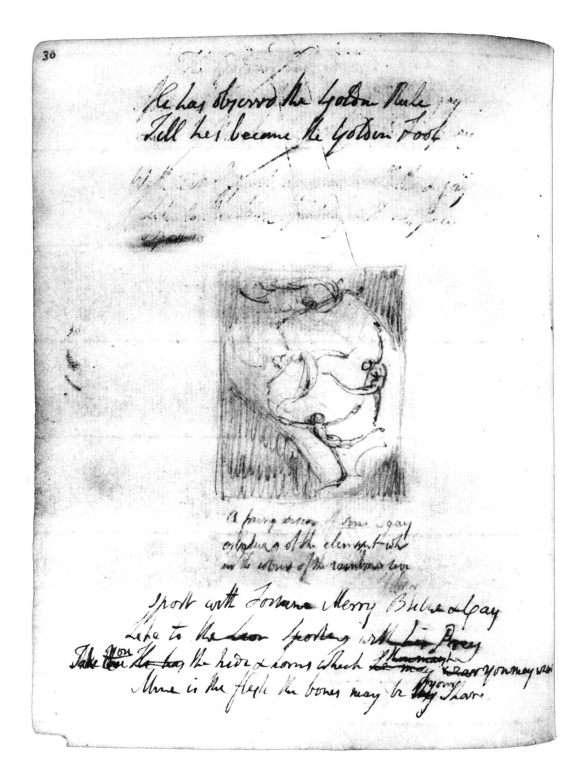

Figure 2. Blake's Notebook, page 30, related to plate 2

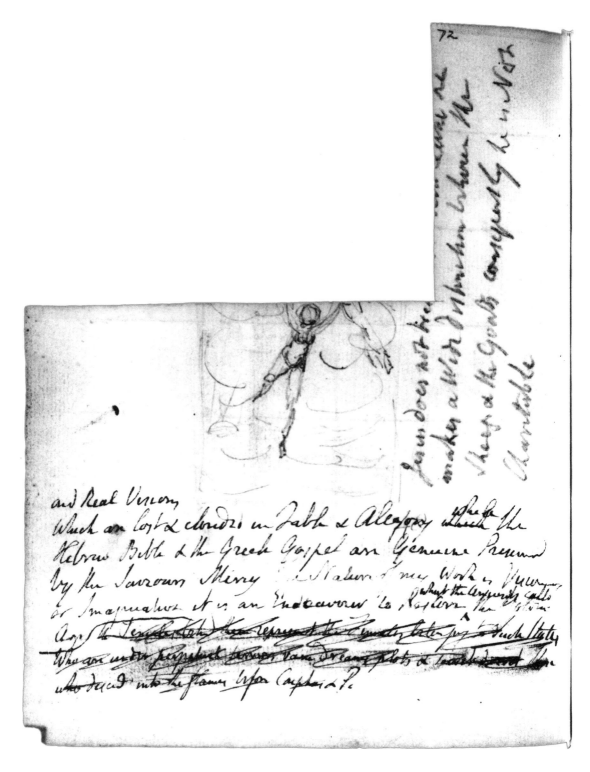

Figure 3. Blake's Notebook, page 72, related to plate 2

Figure 4. Blake's Notebook, page 81, related to plate 2

right, is based on yet a third emblem drawing, where he is already associated with clouds and rain (figure 4). A separate pencil sketch of a similar figure is now in the Houghton Library, Harvard University. The catalogue of figures on Notebook page 74 (figure 1) may have also provided some pictorial resources. The two drawings of demonic heads, bottom left and center, are very similar to the face of the winged figure pursuing the running woman. He combines the beard of the sketch bottom center with the arm position (if indeed those are arms beneath sleeves or a cloak) of the sketch bottom left.

Blake's borrowings from, and thus allusions to, Fuseli offer more than an opportunity to compose art-historical footnotes. Fuseli's art was notorious for its investigations of the relationship between sex and violence. This feature of Fuseli's work indicates a thematic link to, and a pictorial appropriateness for, a text that (as we shall see) begins with a rape and interrogates its consequences. A biographical dimension is also hinted at by Blake's insistent pictorial borrowings from Fuseli, here on the title page and throughout his designs for *Visions*. Beginning in the autumn of 1790, Mary Wollstonecraft (whose works Blake illustrated) was enthralled by an intellectualized passion for Fuseli. Their friendship ended late in 1792 when Mrs. Fuseli denied the philosophical feminist access to her home and to her husband's affections.[11] Accordingly, the echoes of Fuseli in the pictorial dimension of *Visions of the Daughters of Albion* can be associated with masculine responses to female sexuality, at issue in both Blake's poem and Wollstonecraft's *Vindication of the Rights of Woman*. At the very least, it seems probable that these visual and textual engagements developed within the context of the human relationships in Blake's circle of acquaintances.

The title words present their own echoes and complexities. "Albion" is a traditional personification and name for England, and thus the "Daughters of Albion" would be the same group that formed one of the main intended audiences for Wollstonecraft's *Vindication of the Rights of Woman*. Blake's title even shares with Woll-

stonecraft's similar initial "V" and concluding "-ion" sounds, the same syntax, and the same preposition and definite article in the same sequence. That small linking word—"of"—creates some significant ambiguities in *Visions*. Are the Daughters the ones having the visions, or are they the object of someone else's visions? If we assume the former, then two further possibilities arise: are these the Daughters of Albion who have undescribed visions, or are these Daughters (of undescribed parentage) who have visions of Albion/England? The absence of certain answers tends to make us question the usual distinctions between the perceiver and the thing perceived in ways that correspond to the influence of the subject on the object, of mind on matter, so much a part of Blake's thought:

> What is now proved was once, only imagin'd.
> (*The Marriage of Heaven and Hell*, E36)

> For the Eye altering alters all
> ("The Mental Traveller," E485)

> As the Eye—Such the Object
> (Annotations to Reynolds's *Discourses*, E645)

But we can reach far beyond the context of Blake's writings to find disruptive pronouncements on the relationship between subjectivity and objectivity. The ways in which external reality is constituted by its perception, and the importance of mind in the organization of those perceptions into an ordered world, are among the most significant issues addressed by eighteenth-century philosophy from George Berkeley to Immanuel Kant. The syntax of Blake's title initiates the poem's participation in that grand debate.

A great deal of interpretive energy has been expended in attempts to understand Blake's (purposefully?) cryptic motto written on the waves: "The Eye sees more than the Heart knows."[12] "Thel's Motto" from *The Book of Thel* offers an intriguing predecessor:

Does the Eagle know what is in the pit?
Or wilt thou go ask the Mole:
Can Wisdom be put in a silver rod?
Or Love in a golden bowl? (E3)

No matter what answers we might offer, the terms of these questions center on different kinds of perception (the perspectives of the eagle and the mole), knowledge, emotion, and the implied relationships among these three concepts. The motto on the *Visions* title page engages these same issues. The sentence would be easier to understand, and more in tune with many of Blake's statements on the superiority of inner knowledge to outer perception, if it were reversed: "The heart knows more than the eye sees." I am tempted to claim that Blake simply made a mistake when writing the motto on the plate, much as he did when he failed to reverse the letters of his imprint in *There is No Natural Religion*, but this easy solution is made suspect by the fact that Blake printed the motto as it stands in all recorded impressions. If the eye sees more than the heart knows, then there is a deficit in our knowledge in relation to the full content of perception. Isaiah 6:9 would seem to make the same point: "Hear ye indeed, but understand not; and see ye indeed, but perceive not." Perhaps we need to search through what we see more carefully, gaining in wisdom not through more visual experience but through a deeper understanding of what we have already seen. Whether the object of our vision is the world, or ourselves—or an illustrated poem—a more searching investigation of what lies before us would seem to be the best way for the heart to catch up with the eye. The heart is generally associated with feeling rather than knowing, and thus "Heart knows" implies a connection between the organs of knowledge and emotion, linked in turn to the organs of perception, much as in "Thel's Motto." We should be alert to the reappearance of these concepts and how they relate one to another, or fail to relate, in the body of the poem.

Readers generally overlook the publisher's imprint in a book, or at least consider it irrelevant to an understanding of the text. Blake's illuminated books instruct us to consider all their dimensions, visual, verbal, and bibliographic. The imprint clearly states who printed *Visions* and when, but it also registers the absence of some information we normally expect from a title page. Who wrote this book? Who illustrated it? Eighteenth-century title pages generally gave the publisher's name—a bookseller or a consortium of booksellers—and the place of publication. Blake seems excessively reticent in not recording these basic facts. The answer to all these questions is of course "Blake," but here he takes credit only for printing the book. In the imprints to *There is No Natural Religion, Songs of Innocence*, and *The Book of Thel*, Blake used a more forthcoming formula, "The Author & Printer . . . Blake"; *The Marriage of Heaven and Hell* offers nothing but the title. In his illuminated books, with the exception of *Songs of Experience*, Blake continued to name himself only as the printer through the remainder of the 1790s. He would seem to be playing off against the bibliographic standards of his day, revealing them *as* conventions by deploying them only in fragmentary forms.

SECOND OPENING: PLATES 3 AND 4

Blake continues to evoke, but immediately disconcert, eighteenth-century norms on the third plate. It was common to preface a narrative poem, although usually one of greater length than *Visions of the Daughters of Albion*, with a prose "Argument" that summarized the main action of the text in a straightforward manner, rather like an extended table of contents. Blake used brief "Argument[s]" to initiate his line of reasoning in *All Religions are One* and *There is No Natural Religion*; neither serves as a summary of the whole work. "The Argument" at the start of *The Marriage of Heaven and Hell* is a verse narrative with a mysterious, but probably allegorical, relationship to the prose text that follows. *Visions* continues at least portions of this reversal of conventional expectations by offering a verse (rather

than prose) "Argument," with lines approximately half the length of the poem it introduces. The two quatrains provide an overview of events subsequently related in more detail, but these are completed by the end of the next plate. Blake would seem to be using the "argument" genre less for purposes of clear summary than as a means for relating the same actions from slightly different perspectives. "The Argument" is a first-person narration by the woman—we will learn her name on the third line of the next plate—at the center of the poem's action; the remainder of the text is a third-person narrative, albeit with many quoted speeches by the principal characters.

"Theotormon" (3:1) introduces the complex issue of the curious names Blake used throughout his narrative poems. Scholars have found sources, or at least etymological roots or punning precedents, for many of these names in an attempt to elucidate their references and allegorical meanings. "Theotormon," for example, may be a pun based on the English "torment" and the Greek "theo" (god); hence, his name means "tormented by god." The Hebrew word for law, "torah," suggests an alternative: "tormented by law." "Theotormon" also echoes "Tromáthon" (a place) and "Torthóma" (a character), both of which appear in James Macpherson's prose renditions of the poems of Ossian, published in the mid-eighteenth century as purported fragments of the oldest Celtic verse.[13] Although the bard Ossian was a complete invention, and the poems were not translations but loose evocations of Scottish stories, Macpherson's works were widely influential and believed by many to be genuine. Near the end of his life, Blake made his opinion clear in his annotations to William Wordsworth's 1815 edition of his *Poems*: "I Believe both Macpherson & [Thomas] Chatterton [a forger of medieval verse], that what they say is Ancient, Is so" (E665).

The several possible sources for "Theotormon" suggest that the name indicates an Ossianic character tormented by a legalistic god who has both classical and Hebraic precedents. Such compounds of reference and meaning are typical in Blake's onomastic coinages;

it would be wrong to select just one source or allusion and discard all other possibilities. Like Macpherson and Chatterton, Blake was attempting to re-create an ancient world; unlike them, he did not pretend that his poems were translations of actual ancient texts. Instead he combined borrowings from various traditions with his own imaginative re-creations of the past. With their multiple allusions to Greek, Hebraic, and Celtic words, the names suggest an antediluvian time when these cultures, and their languages and poetry, were still one. Blake's work thereby offers a synthetic counterpart to eighteenth-century comparative analyses of myths that attempted to discover the common substructure and origin of all ancient legends.[14] As is often the case in the arts, what seems most innovative, even bizarre, is inspired by a return to half-forgotten or unexplored traditions.

We learn from the first quatrain of "The Argument" (3:1–4) a good deal about the speaker and what befalls her. Further, if we are permitted to maneuver back and forth between the ancient context evoked by the poem and the context of late-eighteenth-century British culture, we can also find the first hints of a developing social commentary. The central figure in the drama immediately announces her love for Theotormon, lack of shame, and virginity. The last of course accords with concepts of female virtue in Blake's culture. An absence of shame, however, violates traditional values because it suggests immodesty. Wollstonecraft devotes an entire chapter of her *Vindication of the Rights of Woman* to "Modesty," including its relation to chastity, in an attempt to redefine both as active virtues of character rather than symbolic values imposed on women by men. Yet, even Wollstonecraft—generally more puritanical than the author of *The Marriage of Heaven and Hell* and more inclined to improvements in reason than "an improvement of sensual enjoyment"—states that "the want of modesty, . . . I principally deplore as subversive of morality."[15] Although the woman in *Visions* may have "trem-

bled" with a mixture of sexual excitement and apprehension, in spite of her lack of "shame," her transgression of a conventional feminine virtue contributes a societal dimension to her "fears" (note the plural). She may be hiding from censure or worse when she retreats to "Leutha's" valley. A more fundamental issue than immodesty is indicated by the very fact that this woman has announced her love, directly and without shame. This assumption of agency on the part of a woman who boldly acts and speaks is itself suspect from the perspective of late-eighteenth-century culture, particularly when the topic is sexual love. John Gregory, in his popular and influential treatise on female behavior, *A Father's Legacy to His Daughters* (1774), declared that "it is a maxim laid down among you [women] and a very prudent one it is, That love is not to begin on your part, but is entirely to be the consequence of our [men's] attachment to you."[16]

"Leutha's vale" introduces another mythic name. Once again there are precedents in Ossian ("maid of Lutha" in "Oina-Morul"[17]) and perhaps a distant echo of Leucothea, goddess of the dawn in Greek mythology. The "Vale of Leutha" also appears in an unpublished plate Blake executed for *America* (E59); and the character plays a substantial role in *Milton a Poem*, where she is a seductress. We cannot automatically assume that whatever symbolic meanings the word takes on in later poems necessarily pertain to this first appearance in *Visions*, but female sexuality would seem a common thread linking these several contexts. Although it may at first seem an unwarranted interpretive leap, the metaphoric breadth of Blake's writings, and in particular the concern with the body and its senses central to later plates in *Visions*, prompt an association between landscape and body-scape, between "Leutha's vale" and the female genitals. Rather than expressing her love openly, the speaker of "The Argument" sequesters her passion in the most hidden parts of her anatomy. In spite of her direct assertion to the contrary, such an act suggests the psychology of shame as the internalization of social forces that determine a female's attitude toward her own sexuality.

This will not be the only time that we will find the central figure of the poem poised uncomfortably, even self-contradictorily, between incompatible positions. Much of Wollstonecraft's *Vindication* struggles to disentangle similar contradictions in masculine desire and its pervasive influence on women's lives.

The second quatrain quickly summarizes two dramatic events. By extending the body/landscape metaphor, we can read the literal deflowering in Leutha's vale as a metaphoric one—that is, "deflowering" as the loss of virginity. What is striking, even revolutionary, about this rite of passage into sexual experience is the woman's agency: "*I* plucked Leutha's flower." Even if we read the passage as indicative of the woman's acceptance of her sexual nature rather than as a metaphor for autoeroticism, the event still unfolds without a male presence. That presence emerges in the final two lines of "The Argument." "Thunders" have masculine associations extending back to Zeus, while the "virgin mantle" rent by that terrible force suggests the hymen, similarly referred to near the conclusion of *The Book of Thel* as "a little curtain of flesh on the bed of our desire" (E6). The swiftness with which the woman's sexual self-possession is followed by sexual violence suggests that the latter is an expression of male vengeance for the former. Such an act of reprisal would be consistent with an ethical, even theological, position of the sort Blake criticized when, in 1788, he annotated a copy of Fuseli's loose translation of J. C. Lavater's *Aphorisms on Man*. There Blake claims that the "or[i]gin" of repressive moral codes is the "mistake in Lavater & his cotemporaries . . . that Womans Love is Sin" (E601). Fearing female sexuality when not stimulated and controlled by men, they brand it a sin to justify violent punishment and attempts to reestablish domination.

⁓

The final lines of "The Argument" recall the major figures grouped on the title page. The winged demon

soaring through a stormy sky and the female he pursues offer a pictorial equivalent of the "terrible thunders" and the speaker of "The Argument." The immediate source for Blake's winged figure, Fuseli's rain god in Darwin's *Botanic Garden*, has lightning bolts extending from his hands and thus is clearly associated with thunder.

The mildness of the design on plate 3, for which the delicate watercolors of the Huntington copy seem most appropriate, contrasts strongly with the violent conclusion of the text immediately above and with the images on the previous two plates. Blake has moved rapidly from the sublime—indeed, the horrific sublime—to the beautiful. This change in aesthetic categories also registers a shift from a masculine to a feminine perspective in accord with the speaker's gender on plate 3. A young girl, nude but indicating a touch of modesty by folding her hands over her breasts, kneels on the ground and leans forward, perhaps about to kiss the energetic figure who soars upward from one of the two spiky blossoms growing from the sinuous plant, lower right. It can be dangerous merely to assume the gender of Blake's figures based on body type; for example, the feminine figure in a long gown pictured in "The Little Boy Found" (*Songs of Innocence*) is Christ, according to the text of the poem. In this instance, however, it seems safe to identify the hovering form as a female. The design does not directly illustrate any portion of the text on the same plate, as is frequently the case in the illuminated books; but clearly the event pictured must have occurred before the onrush of the "terrible thunders." The kneeling woman's hair is pulled back into a bun, but loose strands wave above her back. Like her hair, the woman is moving from restraint to freedom. The figure seen from behind may be the personified form of the flower; if so, then the design can be associated with plucking "Leutha's flower." Even if we identify the soaring figure as a projection of the kneeling woman's erotic imagination, rather than as a separate female being, the scene still suggests lesbian sexuality. The design thereby supplements the transgressive implications of the text.

The rays of light, evidently emanating from an unseen rising or setting sun and extending upward from lower right, underscore the similarity between the design on plate 3 and a brief lyric, entitled "Eternity," that Blake wrote in his Notebook c. 1793:

> He who binds to himself a joy
> Does the winged life destroy
> But he who kisses the joy as it flies
> Lives in eternity's sun rise (E470)

The first line also reminds us of the several forms of destructive bondage pictured on the frontispiece to *Visions*. These multiple parallels exemplify Blake's habit of deploying similar images in two media, pictures and words, without necessarily bringing the two into physical proximity. While such parallels can be intriguing, even illuminating, it is not easy to integrate them into an interpretive methodology. It would be wrong, for example, to conclude immediately that the diminutive figure on plate 3 is identical to the "joy" in the Notebook poem and consequently exclude other identifications suggested by the text of *Visions* itself. But it is also difficult to avoid reading the Notebook verses as an appropriate textual accompaniment for the design on plate 3. Blake often tempts his readers to assemble their own combinations of his words from one artifact and the pictures from another.

The preliminary drawing for the design on plate 3 appears on page 28 of Blake's Notebook (figure 5, in which three lines of later ink writing have been digitally removed from the upper reaches of the sketch). There is only one flower represented in the drawing, but the disposition of the two figures is very similar. The shortening of the rays of light in the etching was necessitated by its horizontal format, in turn motivated by the space requirements of the text above the design. The drawing even contains the horizontal bands of clouds. Blake etched only a few fragments of these lines on the plate, but in the Huntington impression he added to and emphasized the clouds with watercolors.

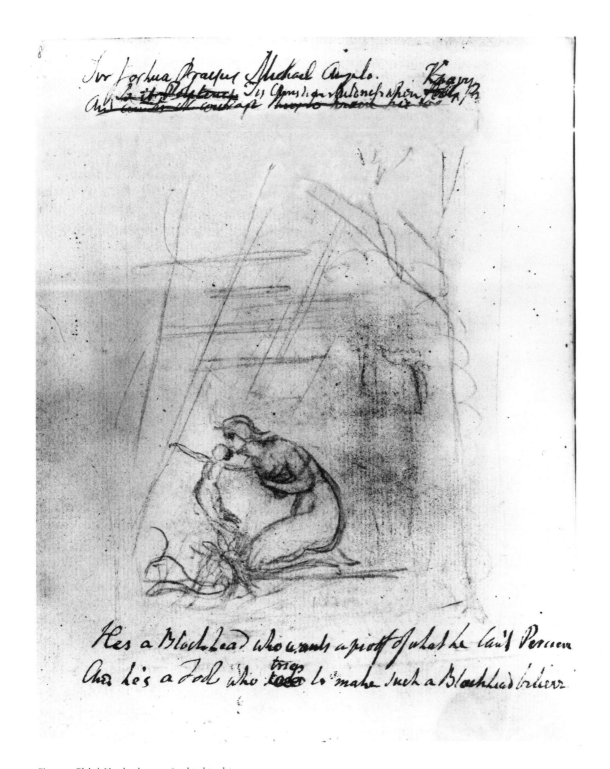

Figure 5. Blake's Notebook, page 28, related to plate 3

The Notebook drawing shows on the right a large tree encircled with a vine and the ghostly outlines of a standing figure just left of the tree. The figure has its legs together, arms bent at the elbows and perhaps crossed over its chest, much like the kneeling woman, and a rather grim expression on its face. A few curling strands of hair float to the right of the figure's head and back. The tree, vine, and standing figure are lightly sketched and may have been partly erased by Blake; the plant and the two figures used in the etching have been added, or drawn over, in much darker pencil lines. The best explanation of this curious combination of motifs is that Blake first composed a design in which the kneeling woman was represented as standing under a tree and observing the flower—and perhaps the soaring figure, if already part of the design—from some distance. The basic format of such a design would be similar to that of the title page to *The Book of Thel*, in which a young woman with long hair stands on the left (right on the copperplate) and, with head tilted slightly downward, looks at flowers and their personifications. Perhaps to distinguish the two designs, Blake moved the standing figure to a kneeling posture and emphasized the motifs in this second and final version of the Notebook design with heavy pencil strokes. In the etching, Blake added the loose strands of hair extending above the kneeling woman's back that, in the drawing, accompany only the standing figure. This chronology of pictorial composition, however, fails to explain the standing woman's visage. The expression of disapproval or sorrow is suggested only by the turned-down corners of her mouth. The single, short line representing her mouth in the preliminary sketch might be nothing more than a slip of the pencil.

⁓

The body of the poem, subheaded "Visions" to distinguish it from "The Argument" on the facing page of the book's second opening, immediately returns us to the imagery of bondage and sorrow (4:1–2). Blake wrote "Enslav'd," the first word in the first line, in larger letters than all the words that follow, thereby underscoring its importance as a thematic "incipit." Even without his experiences engraving plates for Stedman's book about slavery in Surinam, Blake would have known about the antislavery movement in England, one in which women—the "Daughters of Albion" (4:1)—played major roles.[18] Wollstonecraft believed that the women of England suffered under their own type of slavery: "How can women be just or generous, when they are the slaves of injustice?"[19] Such connections between the lot of English women and African enslavement form the historical matrix for Blake's metaphoric connections. The Daughters are themselves enslaved and, like women active in the antislavery movement, direct their concerns toward the colonized lands where slavery flourished. Yet, the revolution in North America had by 1793 established the United States as an emblem of liberty, a symbolic value Blake would soon acknowledge and develop in his poem *America*. Thus, the Daughters' "sighs" are directed toward "America" as a place of both bondage and liberation. Blake also describes these "sighs" as a "trembling lamentation" that echoes through the landscape of mountains and valleys. These voices of sorrow over loss will also echo throughout *Visions*, becoming one of its major motifs, or perhaps reflecting a genre reminiscent of the Book of Lamentations. In the Bible and in Blake's poem as well, the sounds of grief assume a primitive and immediately emotive equivalent to the classical genre of elegy. Here again, Blake addresses contemporary issues through what he imagines to be the most ancient modes of expression.

Line three provides the name of the woman who undoubtedly speaks "The Argument," Oothoon, and who is further identified as the feminine personification ("soft soul") of America. Like that colonized continent, she is paradoxically both enslaved and liberated. Her name has the double "o" sounds present in many African names in Stedman's book, but another relevant source (or at least antecedent) is once again provided by Macpherson's Ossianic texts. The eponymous heroine of "Oithona"

(see note 13) is "raped" (241) by Dunrommath, Lord of Uthal, and imprisoned in a cave on the island of Tromáthon. The parallels with *Visions* are several, including the similar sounding names of the central female figure, the violation that precipitates the poem, and even the cave imagery so apparent in Blake's frontispiece. The rape and abduction of Oithona are noted by Macpherson in a footnote to the title; the body of his text concerns the consequences for the woman; her lover, Gaul; and Dunrommath. After the first two text plates, *Visions* also centers on the response to rape by the same three character types: the male rapist, the female victim, and the man she loves. Yet these specific parallels are arguably less important than the linguistic and atmospheric texture shared by Blake and Ossian: recollections of extreme violence ending in lamentation, the brooding energy of natural forces both psychic and elemental, and evocations of the primeval. There are of course significant differences between these two texts, but the similarities are sufficient to indicate that Blake is writing in the tradition of Macpherson—or, from Blake's perspective, in the tradition of the oldest British poems.

Much of the text on plate 4 fleshes out what we have already learned, or been able to extrapolate, from the previous plate. The "virgin fears" of "The Argument" can be equated, or at least closely associated, with Oothoon's "woe" that leads her to seek "comfort" (4:3–4) in Leutha's valley. Like Thel in *The Book of Thel*, who converses with a "Lily," Oothoon opens a dialogue with a flower. These speeches, lines 6–10, are indented on the left margin to set them apart from the third-person narrative of the remainder of the text on plate 4. The additional marginal space invited two groups of vegetative flourishes that further highlight the passage. The patterns of dots left of line 8 suggest that Blake originally etched a third vine but then removed all but a few fragments. In copy G of *Visions* (Houghton Library, Harvard University), these remnants are connected with pen and ink lines to restore the motif.

A few words on plate 4 help us understand the design on the facing page, plate 3. In a note to part 2 of *The Botanic Garden*, Darwin claims that "a faint flash of light" can sometimes be seen to "dart from a Marigold," particularly at "sun-set."[20] If indeed the plant pictured on plate 3 is the "bright Marygold" of the text (4:5), then Darwin's comment would explain the association between the flowers and the rays of the setting or rising sun. One shaft of light, far right, even seems to be emanating from the flower just below it. After Oothoon plucks the flower, it will "glow" between her breasts (4:12). Blake leads us into some odd byways in the sciences as well as the arts.

The double perspective concerning the source of light is continued in the design on plate 3 by the double representation of the marigold in both floral and human form. The name given to the latter in the text, "nymph" (4:6), offers some intriguing resonances. In classical mythology, nymphs are semi-divine females associated with nature; in entomology, a nymph is a stage between larva and adult in the metamorphosis of an insect. In both contexts, the word signifies a compound or transitional state, much as Oothoon sees the marigold as "now a flower" and "now a nymph" (4:6–7). Metaphor, including the personification of the flower pictured on plate 3 and analyzed by Oothoon on plate 4, is the rhetorical equivalent to these metamorphoses in perspective or condition. Given the explorations of female sexuality discussed earlier in relation to plate 3, a punning allusion to "nympha," an alternate form of "nymph" and a name for the labia minora, may also be relevant.[21]

Oothoon hesitates to pluck the flower, but the "Golden nymph" assures her that another will grow in its place (4:7–9). The sexual reading of the same act in "The Argument" prompts an allegorical reading of this passage. Oothoon hesitates to enjoy her sexuality, either autoerotically or with a partner, for fear of losing her virginity. The nymph argues, successfully, that the "soul of sweet delight" (4:9) is eternal, for sexual pleasure is repeatable and does not erase the values represented by virginity. The loss of that (false) symbol does not constitute a loss

of virtue. But as Oothoon will soon learn, patriarchy takes a very different view.

In the fourteenth book of the *Iliad*, Juno places a garland between her breasts as a sign of sexual awakening. Oothoon's similar gesture would seem to have a similar meaning and may explain the position of her hands in the design on plate 3. As a consequence of this awakening, Oothoon, like a heliotropic flower,[22] turns her "face to where" her "whole soul seeks"—presumably Theotormon. The next two lines identify Oothoon with the woman running "over the waves" (4:14) on the title page. Formerly hesitant and "mild" (4:8), Oothoon is now "impetuous" (4:15) in her passion as she journeys "over Theotormons reign" (probably meaning his "realm"). But her "delight" is violated as suddenly as in "The Argument." The "terrible thunders" of plate 3, and hence the winged demon on the title page, are now identified as Bromion (4:16), whose name resounds with those of "Berrathon" in Ossian; Boreas, who rapes Orithyia in Ovid's *Metamorphoses*; Bromios, another name for Dionysus in Euripides' *Bacchae*; and—most appropriately—the Greek words for "thunderer" and "roarer." Blake's typical synthesis of Celtic and classical elements to construct names also plays a role in his plots, as noted earlier in regard to Macpherson's "Oithona." The rape of Oothoon finds its classical precedent in the story of Persephone, who is picking flowers in a glade or vale when she is abducted by Pluto and imprisoned by him in the underworld.

The designs on plate 4 recall both the smaller figures on the title page and Fuseli's art of erotic violence. The figures displayed around the plate's title suggest classical myths—especially Venus's counterpart, the huntress Diana—and the imagery of love sonnets reaching back to Petrarch. The female blowing a curved horn, upper left, is based on two small sketches in Blake's Notebook, page 51. She recalls the hunting images so much a part of the man's pursuit of the reluctant woman in love poetry from the fourteenth century to Blake's own time. The gowned woman riding side-saddle on the cloud, just

above the second letter of "Visions," props her head against her raised left arm—a posture traditionally associated with melancholy. Her companion figures, left and right, suggest the melancholy of a lover's broken heart. Two male archers, one about to shoot his arrow and the other reaching over his back, presumably to grab another arrow, easily take their place among the vast array of Cupid figures in European art and literature. The figure with drawn bow is particularly close to an armed cherub in "Falsa ad Coelum," a print about erotic dreams designed by Fuseli and etched by Blake, c. 1790. Below, a hovering female holds in her extended hand a small object from which a liquid seems to be pouring toward the space between "weep" and "a" in the first line of text. Perhaps she personifies the tears of this weeping, but similar motifs have a long history in the arts as representatives of disease (see Revelation 16) or poisoning. The long tail of her gown suggests a serpent. Taken together, these tiny figures would seem to emblematize erotic conflict and its more unpleasant consequences. The dark coloring of the background sky complements their intimations of storm and sorrow.

The vignette below the text on plate 4, like the figures above it, stands in sharp contrast with the design on the facing page (plate 3). A woman (center) and a male (right) sprawl within a rocky, barren landscape. The shapes behind them and on which they lie suggest clouds, but the smaller untinted objects left of the woman appear more rocky than cloudy. The figures' postures are interpretable as indicative of postcoital abandon, or agony, or death—or some hard-to-define combination of the three. The woman's condition suggests Oothoon's, as briefly described in 4:17; but it is difficult to identify the man with Bromion, given the boastful tenor of his speech just above the vignette, unless we are meant to take a single word in 4:17—"appalld"—as the textual cue for his posture in the design. The identifications of the figures are less certain than the ways in which they echo two of Fuseli's most famous paintings: the woman in *The Nightmare* (1781) and Bottom's legs, viewed from much

the same angle as the man's lower right on plate 4, in *The Awakening of Titania*, an illustration of c. 1785–90 to Shakespeare's *A Midsummer Night's Dream*. Blake has added to Fuseli's female a cruciform configuration for her arms that suggests she is a victim, perhaps even a sacrificial victim.

⁓

The remainder of the poem, beginning at 4:18, is dominated by speeches delivered by the three principal characters. These passages constitute less a dialogue than a series of monologues, as though Oothoon's violation creates both a stasis in activity and a breakdown in verbal interaction. It is, however, most significant that Oothoon continues to speak; indeed, she dominates all that follows. Rather than hiding her sexuality, as she did briefly in "The Argument," Oothoon proclaims it. Women's response to rape has historically taken forms directly opposite to these, including guilt, shame, and silence.[23] The fact that Oothoon continues to speak in her own defense itself transgresses eighteenth-century norms. No longer reticent and mild, she is forceful in asserting that her value has not been diminished by Bromion's assault. Indeed, that physical violation raises Oothoon's consciousness of herself and her world—to borrow from the rhetoric of twentieth-century feminism. The tearing (3:7) or rending (4:16) of her hymen and all that it symbolizes in a male-dominated culture has, like the tearing or rending of a veil, opened new vistas.[24] The sometimes tortured, even contradictory, form and content of her utterances bespeak the trauma she has undergone, but we should not overlook the psychologically and politically positive (albeit unintended) consequences of her violation.

The rapist is the first to speak (4:18–5:2). Like Pluto in the Persephone myth and Macpherson's Dunrommath in "Oithona," Bromion appears to have carried off his victim, for Oothoon lies on this thunder-god's "stormy bed" (4:16). Her "woes" appall the abductor's rage and his "thunders" are now "hoarse" (4:17). Rather than responding with sympathy, Bromion claims his dominion.

He defines Oothoon as a "harlot," a self-justifying definition of his victim as someone who is guilty because she has enticed her ravisher and is converted from virgin to prostitute through sexual experience, even if forced upon her. With the same key term, Bromion is also trying to commodify his victim, turning her into a money-producing laborer akin to a slave.

Bromion's statement about "jealous dolphins" (4:19) may be a general reference to the jealousy he assumes his conquest will stimulate in all other males, but it has particular relevance to Theotormon. As we will learn just five lines later, Bromion's speech is addressed to Theotormon, whose association with the sea has been suggested by lines 14–15: "Over the waves she went . . . over Theotormons reign." Theotormon's tormented response to Bromion's speech is to roll "his waves around" (5:3) and "fold his black jealous waters" around rapist and victim alike (5:4). The traditional associations between dolphins and Venus may also lie deep in the background of this unusual image for the lover's jealousy.

The last six lines of Bromion's speech are particularly rich in allusions that underscore the psychic and historical connections among masculine desire in its most aggressive forms—colonialism, the reduction of labor to capital, and the enslavement of Africans. Blake hints at the mechanisms by which the sex drive is perverted into violence—long before Freud—which in turn finds expression in politics and economics. The metaphoric association of Oothoon and America was established by the third line of plate 4; Bromion now proclaims his conquest of those lands, both "north & south" (4:20). In addition to that colonial dominion, Bromion has enslaved Africans—"the swarthy children of the sun" (4:21)—and has stamped his signet, his emblematic initials, upon them. Blake learned of this branding of slaves to indicate ownership from Stedman's book: "The new-bought negroes are immediately branded on the breast or the thick part of the shoulder, by a stamp made of silver, with the initial letters of the new master's name, as we mark furniture or any thing else to authenticate them

properly."[25] Stedman's complicity in these practices is indicated by one of the plates engraved by Blake, entitled a "Family of Negro Slaves from Loango" and showing a brand on the father's right breast that the accompanying text describes as "*J. G. S.* in a cypher . . . by which his owner may ascertain his property" (2:280). Other plates Blake engraved for the book show the torture of disobedient slaves, including two scenes picturing slavemasters holding a rod or whip. His work on these engravings no doubt influenced Blake's reference to "the scourge" that Bromion uses to enforce obedience (4:22). Stedman was deeply involved in the same nexus of sexual exploitation, cruelty, and the imposition of property rights on humans explored by this crucial passage in *Visions*, although the sexual dimensions of the slave trade in Surinam are more clearly set forth in his original manuscript than in the heavily edited published version of 1796.[26]

The last few lines of Bromion's speech reveal the fallacious self-justifications common to the rapist and the slave owner. The daughters of slaves "worship" the violence that terrorizes them into obedience (4:23). Mindful of the rapist's notion that his victim has "asked for" and enjoyed her violation, the master convinces himself that his slaves are pleased to be his property. The economics of possession are the same in both situations and find their political equivalent in the ways European colonialists planted their flags—a symbolic gesture equivalent to stamping their signets—on the virgin lands of America.

THIRD OPENING: PLATES 5 AND 6

The pictorial motifs on plate 5 continue the theme of enslavement. In the horizontal vignette between lines 16 and 17, a man lies on the ground, his right arm bent in a way that suggests he is trying but failing to rise. His skin color, dark brown in the Huntington copy and either black or dark brown in all others, indicates either an African or a native American. He is one of the "swarthy children" (4:21) or "slaves beneath the sun" (5:8) obedient to Bromion. The man's posture recalls the famous classical sculpture of a dying Gaul, a race enslaved by the

Romans. His pickax rests against a leafless tree that leans toward the earth like the man. A female figure falls head first among clouds in the upper left margin. This may be one of the slaves' "daughters" (4:23) or, more interestingly, Oothoon, literally pictured as a "fallen" woman after her rape. Although she is not spatially integrated into the main design, she is thematically related because of the metaphoric connections Blake has established between victimized woman and slave. She is falling into the condition represented by the man, or onto the cloudy bed she lies on in the design at the bottom of the facing page, plate 6.

The second word on plate 5—"thou"—is almost certainly a reference to Theotormon, and thus Bromion's whole speech is addressed to him. Since Bromion (at least in his own eyes) has conquered Oothoon, he can pass her on, like a slave, to Theotormon, whose degradation would be doubled, first by marrying the "damaged goods,"[27] and then by having to "protect the child" conceived by Bromion's "rage" (5:1–2). The poem offers no further indication of Oothoon's pregnancy, and thus it would seem that Bromion's claims about engendering a child may have less to do with biological events than with masculine egos. To impregnate Oothoon is but another way of branding her with his own name and dominion; the "child" is a product of his "rage"—indeed, a projected or reified personification of that rage. Bromion's words suggest the modern insight that rape has its psychic origins in anger more than in lust. His rhetoric, in this address to Theotormon, further suggests that the ultimate object of his fury is the man; the woman is only a vehicle for asserting dominion over another male. By raping Oothoon, Bromion rapes her lover. The parallel between Bromion's physical attack on Oothoon and his verbal attack on Theotormon is underscored by Blake's use of the same word—"rent" (4:16 and 5:3)—to describe both Oothoon's rape and the effect Bromion's words have on Theotormon. The raped woman, the slave, and the conquered land all become fungible commodities, an equivalent of monetary exchange, for establishing power relationships among competing males.[28]

Theotormon's nonverbal response to Bromion's masculinist challenge includes a description of the cave and bound figures of the frontispiece, although Blake's syntax (5:4–5) does not specifically indicate that Theotormon is their imprisoner. This passage makes it clear that the male and female shackled back to back are Bromion and Oothoon, although they are also described as personifications of two emotional states, "terror & meekness" (5:5). The third figure in the frontispiece is Theotormon, described in the text as "wearing the threshold" of his cave with his "secret tears" (5:6–7). The self-involvement of his contracted posture, turning his body into yet another enclosed cavern, implies that the tears are for his own plight, not Oothoon's. The expression on Bromion's face indicates that the terrorist is himself feeling terror; like the slavemaster, he is as much bound to a degrading and pernicious—indeed, terrible—system as his slaves. Oothoon appears meek in the frontispiece and at this point in the narrative; but, like the "just man" who was "once meek" but now "rages" in "The Argument" to *The Marriage of Heaven and Hell* (E33), she will soon begin an attempt to overcome that unproductive stance. Her equally unproductive, uncommunicative bondage to Bromion suggests a social context in which the female victim, inevitably and principally labeled as a "victim," is never free from the definition imposed on her by her ravisher's actions. Their mutual imprisonment also recalls the fate of another "adulterate pair" (5:4), Paolo and Francesca in Dante's *Inferno*, whose punishment includes being together in hell forever.

The text now journeys into what lies "beneath" (5:7) Theotormon. Not surprisingly, we find there a landscape of waves and desolate shore resembling those represented on the frontispiece, which immediately becomes a simile for the "voice of slaves beneath the sun" (5:8). The relationships among the three main characters in *Visions* have their foundation in the same metaphoric (but more-than-metaphoric) connections among rape, slavery, and colonialism that underlie Blake's rhetorical strategies and historical perceptions. Blake adds to this circle of reference an additional dimension, religion.

Later passages will enrich his reference to "religious caves" (5:9), but suffice it to say at this juncture that Blake is here suggesting connections between institutionalized religion, as a mode of repression, and the destructive acts and institutions already explored by his narrative. Such repression lies at the origin "beneath" (the third use of the word within three lines) the "fires / Of lust" (5:9–10) that rise from the depths of the psyche and explode destructively, like lava from a volcano.[29] The implication here that violence is the product of desire deformed by repression also lies behind one of the most controversial "Proverbs of Hell": "Sooner murder an infant in its cradle than nurse unacted desires" (*The Marriage of Heaven and Hell*, E38).

Characterizations of the principal males concluded, Blake turns to Oothoon. Her "tears are locked up" (5:11), as if the silence imposed on violated women has extended even to that mode of expression. But this imprisonment of sorrow's images may be a purposeful first step toward liberation from the traditional role of the weeping woman, a role filled earlier by Theotormon, himself victimized and feminized by Bromion's violence. Other forms of prelinguistic utterance ("howl") and gesture ("writhing") remain available to Oothoon (5:12).

The next line (5:13) initiates an exploration of Oothoon's complex psychological state and its mythic background. By calling on "Theotormons Eagles to prey upon her flesh," an event pictured unequivocally at the bottom of the facing page, Oothoon invites a symbolic repetition of her rape. The eagles will "rend their bleeding prey" (5:17), just as "Bromion rent her with his thunders" (4:16). Blake sketched a preliminary drawing for the design for plate 6 on page 32 of his Notebook (figure 6, in which ten words of unrelated text obscuring the tips of the eagle's wings have been digitally removed). The etched version closely follows this pencil sketch. Oothoon's posture emphasizes the sexual implications of the scene and once again recalls Fuseli's *Nightmare*. Why does she wish for this (re)punishment? One possible

motivation is to demonstrate that such physical attacks do not violate her identity, value, and love for Theotormon. Yet, in her speech of three lines, Oothoon refers to her "defiled bosom" (5:15). The adjective indicates that she has accepted at least a portion of the masculinist ideology of rape—namely, that the woman is corrupted by her victimization. The internalization of the conqueror's values by the conquered is a well-documented phenomenon, but Oothoon's readiness to play this role is more than a little disturbing, particularly given her earlier revolutionary stance in regard to female sexuality. But the same might be said of Mary Wollstonecraft, whose passion for Fuseli and, later, her unhappy affair with Gilbert Imlay hardly seem consistent with the rationalist views she propounds in *A Vindication of the Rights of Woman*.

Oothoon hopes that her defilement will be cleansed by sexual submission to her lover's desires, imaged in the poem as his eagles. The birds of prey will remove her flesh, like an unclean garment, and return Oothoon to a transparency indicative of moral purity, like the clearing of a "spring mudded with the feet of beasts" (5:19). Thus, the second rape is an inverted reflection of the first and will have opposite consequences: purifying rather than polluting, uniting her with Theotormon rather than alienating her from him. Her "transparent breast" will reveal the "image of Theotormon" and "reflect" his "smiles" (5:16, 18). This process, both narcissistic and domineering, recalls the many images in Renaissance love poetry of the way the beloved's image is reflected by the eyes, or engraved in the heart, of the lover. More generally, these lines indicate the expectation that a woman's emotions should reflect the man's. This passage reflects the norms for female behavior, particularly in regard to sexual love, that were operative in Blake's culture, as exemplified by John Gregory's instructions quoted earlier.

The images or inscriptions on Oothoon's breast, like the signet stamped on the breast of the slave, signify the values of her androcentric culture and suggest a parallel between African enslavement and female bondage to the conventions of traditional romantic love. It would be convenient, particularly for admirers of Blake's art and ideas, to separate the poet from his heroine at this and other junctures in the text and claim that he is insightfully dramatizing the baneful influence of those systems and the values they institute. But before we leap to that conclusion, we should consider the possibility that Blake was a man of his times and not a seer of modern consciousness, a man who may have been, like Oothoon, only partly aware of the ways arbitrary social forms represent themselves as universal truths. Attempts to see Blake as prophetically repudiating male predominance must take into account one of his 1788 annotations, written privately, to Lavater's *Aphorisms*: "the female life lives from the light of the male" (E596).

The references to eagles and what they do to Oothoon recall the story of Prometheus.[30] The Titan stole fire from heaven and gave it to mankind. Zeus punished him by chaining Prometheus to a rock where a vulture fed daily on his liver. Oothoon is similarly punished by birds of prey for seizing the fire of sexual gratification for herself. In Christian interpretations of classical mythology, Prometheus was taken to be a typological foreshadowing of Christ. It can be hazardous to convert a two-phase allusion of this sort into meaning; but if we take a broader approach in this instance, then Oothoon is both a type of Prometheus and a type of Christ, a female hero of revolt against reigning powers who willingly takes on a sacrificial role. Her call upon the eagles "with holy voice" (5:14) hints at a Christian context. A concept of vicarious atonement might explain why Oothoon so eagerly seeks punishment—not for her own sins (she has committed none), but in compensation for Bromion's. Yet, given Blake's later criticisms of the doctrine of atonement,[31] a veiled reference to Christ's sacrifice on humanity's behalf enriches without clarifying this complex interweaving of allusive imagery, psychology, and ideology.

Oothoon has tried, but failed, to do what Wollstonecraft believed no woman could: "A woman who has lost her honour, imagines that she cannot fall lower, and as for recovering her former station, it is impossible;

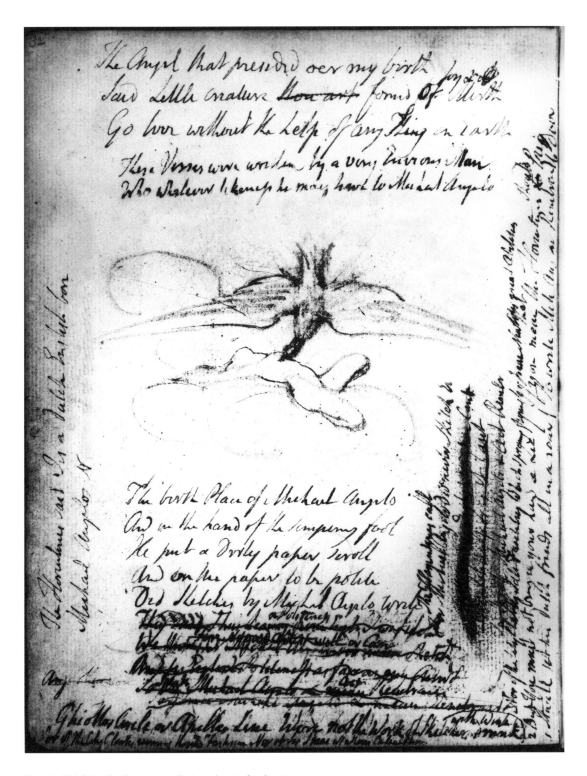

Figure 6. Blake's Notebook, page 32, preliminary drawing for plate 6

no exertion can wash this stain away."[32] Theotormon "smiles," but only "severely" (5:18), as though he is taking ironic or sadistic pleasure in Oothoon's torture. No further response is forthcoming; instead, the "Daughters of Albion" are the only ones to hear Oothoon's "woes" (5:20). Here and at two further moments in *Visions* (8:2, 11:13), the Daughters act as both audience and chorus, like the chorus in Greek tragedy or the "daughters of Jerusalem" in the Song of Solomon. Yet they add nothing to the discourse, for they only "eccho back" Oothoon's expressions. All the females, like the thrice-repeated refraining line itself, seem imprisoned within an echo chamber that leaves their attempts at dialogue unfulfilled, their appeals and questions unanswered.

~

After she hears Theotormon's minimal and equivocal response, Oothoon acknowledges that her words and actions have been "in vain" (5:22).[33] She tries once more to raise him to action in a lengthy speech extending from 5:23 through 6:20. This section of *Visions* has been largely overlooked by modern interpreters, probably because it delves into some rather obscure eighteenth-century debates over the nature of the senses and does not speak directly to the issues of sex, slavery, and colonialism of central interest to modern commentators.

Oothoon's renewed burst of energy—"I cry arise O Theotormon"(5:23)—echoes the Song of Solomon: "My beloved spake, and said unto me, Rise up, my love, my fair one, and come away. For, lo, the winter is past, the rain is over and gone; The flowers appear on the earth; the time of the singing of birds is come, and the voice of the turtle is heard in our land; The fig tree putteth forth her green figs, and the vines with the tender grape give a good smell. Arise, my love, my fair one, and come away" (2:10–13). Like the biblical passage, Oothoon refers to engendering forces manifest in plants and animals as a natural corollary and stimulus to human action. If Theotormon will not respond to her voice and sacrificial offering, perhaps he will respond to that part of his being he shares with nature, just as the "pure east" (5:26) corre-

sponds to the purity Oothoon insists is hers: "Arise my Theotormon I am pure" (5:28). In this instance, however, the natural metaphor tends to confirm Oothoon's continued construction of her identity on the basis of the dominant ideology, one in which purity is a central ingredient in the commodification of the female. This alone should make us suspect that the references to nature have their limitations. As Blake wrote in his annotations to Dante, c. 1800, "Nature Teaches nothing of Spiritual Life but only of Natural Life" (E634). Yet the next twist in Oothoon's complex speech, structured by metonymy more than logic, demonstrates how even animals can lead us beyond mere natural perceptions.

"They told me that . . ." (5:30) initiates a new level of critical consciousness in Oothoon's language. "They" are the anonymous forces that convince humans of their finitude, a group that includes the rationalist believers in the doctrines of Bacon, Newton, and Locke. This attribution of what we usually construe as natural limits to an ideological source—rationalist doctrine—undermines the usual distinction between culture and nature. As he had already proposed in *There is No Natural Religion*, and as he would soon begin to explore in detail in *The Book of Urizen*, Blake suggests here that the limitation of perception to our physical organs of sense is in fact imposed culturally and that this constraint underlies and limits all other systems of thought and action. Simply by claiming that she was "told" that "night & day were all that I could see" (5:30), Oothoon opens that limit to suspicion; "they" may have been wrong, just as wrong (and as self-serving) as Theotormon and Bromion in their perceptions of Oothoon. Similarly, Oothoon begins to question the prison of the "five senses" (5:31); she is only a step away from Blake's bold pronouncement in *There is No Natural Religion* that "Mans perceptions are not bounded by organs of perception. he perceives more than sense (tho' ever so acute) can discover" (E2). If mind is dependent on those same senses, then it too is in "a narrow circle" (5:32) like the cave/skull of the frontispiece. Yet, Oothoon steps out of that enclosure with the words "infinite brain" (5:32). Even to conceive of that

infinitude is to intimate an expanse beyond the cave of the senses. What Blake began to propose no later than 1788, and what Oothoon is moving toward, is a philosophy of mind extending to a multiplicity and culminating in an infinity.

Oothoon's images of a sinking heart, like a "red round globe" (5:33), and of an oxymoronic "bright shadow, like an eye / In the eastern cloud" (5:35) recall the sun / eye of the frontispiece. Both images also indicate Blake's habit of combining—through simile, metaphor, and other forms of poetic association—psychological, physiological, and cosmological realms. But such expansive modes of thought, like Oothoon's words, are beyond Theotormon's perception. Rather than infinite variety, he sees only sameness: "to him the night and morn / Are both alike" (5:37–38). The depths of his unresponsiveness are plumbed by the first line on plate 6: even Bromion can "hear" Oothoon's "lamentations," but Theotormon cannot.

Oothoon's speech now turns to a series of animal references. The first three lines (6:2–4) all begin with the same three words: "With what sense. . . ." Other examples of anaphora—the beginning of two or more successive lines of verse with the same word or words—appear at 6:22–24, 7:3–4, 20–23, and 8:12–14. In other passages, Blake strays from strict anaphora but continues with similar-sounding initial words—for example, "Who," "How," "With," and "What" (8:15–19). These patterns add an incantatory rhythm to the verse and, when the stress is on "H" and "W" sounds, echo with lamentation, as in the word "howl." When the verse expresses unanswered (perhaps unanswerable) questions, an air of mystery and irresolution also suffuses the lines. These and other repeated patterns, such as frequent plays on "i" and "o" sounds, associate *Visions* with eighteenth-century theories about the oral and formulaic nature of the earliest poetry, including Homer and the Bible. Robert Lowth's theories about parallelism in the Bible may have had a direct influence on Blake's attempts to incorporate an aspect of antiquity in the aural dimension of his poetry.[34]

Oothoon's first three questions (6:2–4) are rhetorical and suggest the existence of a "sixth" or innate sense: chickens know a hawk is near even if they neither see nor hear it; homing pigeons can return to their unseen roost from great distances; bees form precise honeycombs even though they have never been instructed in geometry. Throughout this verse paragraph, Oothoon is wrestling with the Lockean proposition that Blake summarized in *There is No Natural Religion*: "From a perception of only 3 senses or 3 elements none could deduce a fourth or fifth" (E2).[35] Rather than taking this proposition as evidence that there is no sixth sense, Blake leaps beyond Locke's argument, proposing that all humans have powers of perception beyond those of the five senses while implicitly accepting the argument that those powers cannot be logically deduced from the physical senses—logic being incapable of discovering that which exceeds it. Those extrasensory capabilities, however, can be recognized through a reflection on the full range of human experiences that does not exclude desire and imagination. Oothoon extends this belief in innate capabilities even to the animal kingdom. At this point in her speech, she is less a dramatized character, burdened with the trauma of rape and its aftermath, than a mouthpiece for Blake's ongoing attack on the "Philosophy of Five Senses . . . of Newton & Locke" (*Song of Los*, E68). The rapidity of Oothoon's movement from addressing the immediate tyrannies of her situation to the tyranny of the limited senses indicates that Blake links them to the same fundamental errors in thought and deed.

Oothoon turns to "the mouse & frog" (6:4) to add a further dimension to her anti-Lockean argument. These creatures have the same senses, "eyes and ears and sense of touch" (6:5), yet they differ in their habits. Other differences abound among the ass, camel, wolf, tiger, worm, snake, and eagle (6:7–12). What can explain these differences? Only some internal "sense" that determines behavior, as various and individual as the appearance of each creature. Although not as extensive as the catalogue of plants in Darwin's *Botanic Garden*, Oothoon's bestiary similarly stresses variety, with a further implication that it is the right of each animal to behave in its individual

way. Modern science turns to evolutionary theory and genetics to explain the proliferation of difference; for Blake, the phenomenon had a spiritual source, like the "Poetic Genius" he finds within all "men" as the common origin of their religious belief, "tho' infinitely various" (*All Religions are One*, E1–2). At the culmination of this portion of her speech, Oothoon turns from animals to humans and from the biological to the epistemological. The "thoughts of man" (6:13), immaterial and transcendent, are just as hidden as the source of animal variety for those who believe reality is limited to the physical world and the senses that perceive it.

Her speech having reached a climax of insight and emotional intensity, Oothoon turns once again to her immediate situation, her lover, and her pure reflection of his "image" (6:14–16). Her lamentations and appeals would end if Theotormon would simply "turn his loved [but not loving] eyes upon" her (6:15). To her list of physically sullied creatures that retain their value, all metaphors for herself, Oothoon adds "the soul," which is burdened with "woe," like her own soul (6:17), yet retains its untainted essence. Her insistence on purity, a suspect term in the context of masculinist ideology, can now be seen within the philosophical context Blake has developed through Oothoon's speech, one that insists on a concept of identity unshaken by the hazards that befall the body.[36]

Finally, Theotormon replies (6:22 through 7:11). His speech falls short of what Oothoon, or Blake's reader, might have hoped. There is no sympathy or joy. Oothoon's rhetorical questions evoke philosophical insights, but Theotormon is mired in the interrogative. Each of his questions implies the same fundamental confusion of essence and "substance" (6:23), for he wishes to know the physical location of various presences that have none, including the "thoughts," "woe[s]," and "joys" previously addressed by Oothoon. She made use of observable phenomena, particularly animal behavior, to imply a world beyond matter and the five senses. The physical became a world of motivated metaphors for something greater.[37] Theotormon's material images rise to no such conclusion. His references to gardens, rivers, and houses never become metaphors for spirit but, quite to the contrary, imply the nonexistence of the insubstantial. Because he cannot discover physical locations for thoughts and emotions within his assumed, and very limited, definition of existence, he denies them any reality. Theotormon's questions remain unanswered because the answers are to be found on grounds other than those posed by the terms of his questions. He has learned nothing from Oothoon's impassioned discourse.

Fourth Opening: Plates 7 and 8

The last seven lines of Theotormon's speech on plate 7 ramble into both confusion and despair, the results of his limited vision. When, he asks, will "they" (the "thoughts," "joys," and "loves" of the previous two lines) be renewed, and when will the "night of oblivion" finally be "past" (7:5)? The answer must be "never"—unless the horizon of his mental faculties is expanded to include the immaterial presence of thoughts, joys, and loves. He looks not within himself but to "times & spaces far remote" (7:6) for rescue from his plight. The vague dreaminess of these hopes—and his continued confinement within the categories of time and space—makes their realization impossible. And even if his thoughts could journey to that "remote land" and return to "the present moment of affliction," they might bring back "poison" rather than "balm" (7:8–11). Theotormon is one of those who, desiring "what he is incapable of possessing," will fall into "despair" as his "eternal lot" (*There is No Natural Religion*, E2).

Fear, doubt, and incapacity bind Theotormon to the self-enclosed posture in which he is portrayed on the frontispiece and again at the top of plate 7. The setting of plate 7 also recalls the frontispiece—sea, rocky shore, clouds, and the "red round globe" (5:33) of the sun, almost certainly sinking rather than rising on the horizon lower right. Theotormon "sit[s] weeping upon the threshold" (5:21) of Bromion's "cavern" (7:12). Oothoon,

shackled at the ankle, "hover[s]" (6:14) at his side in a gigantic "Wave," the first word immediately below the design. Her hands are clasped in prayerful supplication. The wave is flame-like, and may also be a visual pun, a "tongue" of the sea extending from the "mouth" of the cave. She no longer strides over the sea, as on the title page, but is confined within Theotormon's "black [or at least dark] jealous waters" (5:5). Although more liberated than her lover, Oothoon is still restrained within the limitations of her body, her ineffectual speech, and the man's false perceptions of her. Rather than directly illustrating a specific passage, the design summarizes and supplements the characterization of Theotormon and Oothoon, and the themes associated with them, presented in the text through plate 7.

Blake twice sketched the design for plate 7 in his Notebook. His first thoughts on paper appear on page 50 (figure 7), just above an unrelated emblem design. (The later ink writing that now obscures this light pencil sketch has been digitally removed in figure 7.) Here we see only the huddled form of Theotormon, Oothoon soaring above, and perhaps slight indications of a wave. A few horizontal lines suggest that her arms are extended rather than clasped together. This first version may not have been executed specifically in preparation for *Visions*. A larger and more developed drawing, directly preliminary to the etching, appears beneath a portion of Blake's essay of c. 1810, *A Vision of the Last Judgment*, on page 92 (figure 8, in which most of the words in eleven lines of unrelated text have been digitally removed from the drawing). The wave and chain on Oothoon's ankle are now clearly indicated. For Theotormon's posture in both drawings and the etching, Blake returned to the figure right of center, and just left of the face in profile, on page 74 of his Notebook (figure 1). This series of three drawings indicates the way Blake used the Notebook for the evolution of his pictorial inventions. (The drawing in an oval frame at the top of page 92 [figure 8], largely obscured by later writing, is for *Designs to a Series of Ballads, Written by William Hayley* [1802] and is not related to *Visions*.)

Bromion's response (7:13 through 7:24) to Theotormon begins auspiciously. There are, he claims, other worlds beyond the five senses that "gratify senses unknown" (7:15).[38] Like Oothoon, Bromion would appear to be questioning Lockean limits. He even states that these other worlds are perceived but remain "unknown" (7:16), much as the motto on the title page claims that the eye sees more than the heart knows. He invokes the "infinite" (7:16) and the "eternal" (7:23, 24), as though he is on the way to the perspective epitomized by the famous first lines of Blake's "Auguries of Innocence":

> To see a World in a Grain of Sand
> And a Heaven in a Wild Flower
> Hold Infinity in the palm of your hand
> And Eternity in an hour (E490)

But the possibility of such insights is quickly thwarted by a return to the sorts of materialist limits previously expressed by Theotormon. The "infinite microscope" (7:16) will not see a world in a grain of sand, for the instrument is only an extension of a known sense, not the discovery of a sixth sense. Seas and atmospheres yet to be discovered by "the voyager" (7:17) are repetitions of what is already known. Bromion exemplifies the predicament described in the "Conclusion" to *There is No Natural Religion*: "If it were not for the Poetic or Prophetic character. the Philosophic & Experimental would soon be at the ratio of all things & stand still, unable to do other than repeat the same dull round over again" (E3). This rationalist philosophy may search through a variety of wars, sorrows, and joys (7:19–21), but ultimately it will try to reduce multiplicity to a single principle applicable to all forms of life, the "one law for both the lion and the ox" (7:22). This is an intellectual tyranny equivalent to Bromion's earlier self-characterizations as a slavemaster; as Blake wrote in *The Marriage of Heaven and Hell*, "One Law for the Lion & Ox is Oppression" (E44). The bondage of his mind leads not to the perception of eternity in an hour but to "eternal chains" (7:23). At the same time that the infinite and eternal are closed to Bromion, grains of sand and wild flowers become,

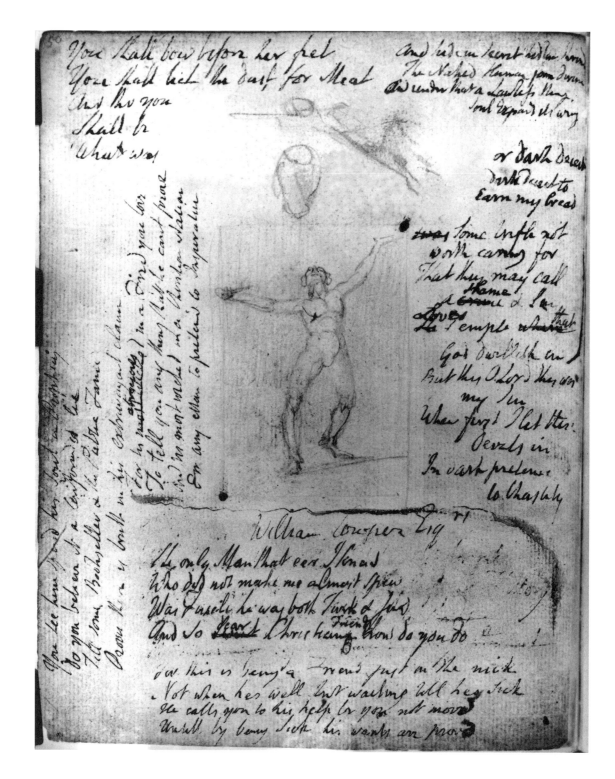

Figure 7. Blake's Notebook, page 50, related to plate 7

represent those who are in Eternity by some in a Cloud within the Rainbow that Surrounds the Throne they merely appear as in a Cloud when any thing of Creation Redemption or Judgment are the Subjects of Contemplation tho their Whole Contemplation is Concerning these things the Reason they so appear is The Humiliation of the Reasoning & Doubting Selfhood & the Giving all up to Inspiration By this it will be Seen that I do not consider either the Just or the Wicked to be in a Supreme State but to be every one of them States of the Sleep Which the Soul may fall into in its Deadly Dreams of Good & Evil when

convince
You may
pretend
to no Corpore
al
& cannot
work of M
to be believ
Honest Men
Things You

& Greeks
will not
Liberty

they have
calld Death
as are in the
ative Groans
are born as
in Mortal
you call
Moral Moral Virtue

& You cannot have Moral Virtue without the Slavery of that half of the Human Race who hate what you Call Moral Virtue

The Nature of Hatred & Envy & of All the Mischiefs in the World are here depicted No one Envies or Hates one of his Own Party even the Devils love one another in their Way they torment one another for other reasons than Hate or Envy those are only employd against the Just Neither can Seth Envy Noah or Elijah Envy Abraham but they may both of them Envy the Success

Figure 8. Blake's Notebook, page 92, preliminary drawing for plate 7

under the dominion of abstract laws based on the rational "ratio of all things," merely "phantoms of existence" (7:24). Bromion has reduced Oothoon's celebration of multiplicity and the "Poetic" character, capable of metaphorizing matter into spirit, to another (and arguably more authoritarian) version of Theotormon's "mind-forg'd manacles" ("London" in *Songs of Experience*, E27). His bondage and images return us, once again, to the frontispiece and underscore its power as a visual epitome of the predicament investigated by the entire poem.

⌒

The final line of plate 7 tells us that Oothoon "waited silent," for a day and a night, apparently with some residual hope that either she or the men who have molded much of her identity will break out of their mutual bondage. On the next, facing plate, she begins her final, insightful lament; it extends from this point (8:3) to the penultimate line of the poem (11:12). Its proportions are consistent with its breadth of reference and allusion. It is a grand summation of what Oothoon has learned, as the result of her violation, yet also an indication of her continued bondage, mental and cultural. But the simple fact that Blake gives these final words to Oothoon, silencing the voices of her rapist and her self-enclosed lover, registers the strength of her presence in this poem, as well as Blake's sympathy for the oppressed. In the refraining line, the "Daughters of Albion" remain an echoing audience for Oothoon's "woes" (8:2).

Her second word gives a singular name to the formerly anonymous and plural "They" (5:30, 31) who have enslaved Oothoon's body and have tried to enslave her mind. "Urizen" appears here for the first time in Blake's writings; he will become a major presence in all of the later mythic poems that delve into the origins of bondage—mental, material, and political. His name has many possible sources and allusions, including "horizon" as a limit on vision.[39] In *The Book of Urizen*, which Blake wrote and etched only one year after *Visions of the Daughters of Albion*, the eponymous anti-hero is the demiurge who separates himself from the other gods in

eternity and, in so doing, falls into and creates the limited world of space and time that he tries to rule through ever-increasing, ever-failing levels of abstract reasoning. He is the ultimate origin of the tyrannies afflicting the characters in *Visions*. That Oothoon is the first to name him indicates her growing insight, as though she were the muse of Blake's evolving myth in all its terrific energy. Her characterization of Urizen as the "Creator of men" in his own fallen "image" (8:3–4) is indeed prophetic of his role in *The Book of Urizen*. He is the god of the "one law" (7:22) espoused by Bromion, a law that works to "absorb" each individual's experiences (such as "joy") into a single entity—"joy" as a linguistic category divorced from its specific human manifestations (8:5). These abstractions ultimately produce sorrow, transforming "joys" to "tears" (8:4). Oothoon protests against this law, claiming that each "different" emotional experience is unique, and in that uniqueness connects us to the "eternal" and "infinite" varieties of life (8:5–6). The singular experiences of "joy" constitute Oothoon's definition of "Love" (8:6). Her perspective accords with Blake's own preference for individual "Minute Particulars" over generalizations:

> General Knowledge is Remote Knowledge it is in Particulars that Wisdom consists & Happiness too.
> (*A Vision of the Last Judgment*, E560)

> To Generalize is to be an Idiot[.] To Particularize is the Alone Distinction of Merit—General Knowledges are those Knowledges that Idiots Possess
> (Annotations to Reynolds's *Discourses*, E641)

> . . . so he who wishes to see a Vision; a perfect Whole
> Must see it in its Minute Particulars; Organized & not as thou
> O Fiend of Righteousness pretendest; . . .
> You accumulate Particulars, & murder by analyzing, that you
> May take the aggregate; & you call the aggregate Moral Law . . .
> (*Jerusalem*, E251)

The next verse paragraph (8:7–32) of Oothoon's great concluding speech is exceedingly complex in its range of reference, possibly ironic use of rhetorical questions, and emotional (even theatrical) subtleties. The "great mouth" (8:7) at the very beginning of the paragraph would appear to be the entry to a "Maw" of "Commerce" (Blake's *Public Address*, E573) that rejects the very concept of a free "gift," much as Theotormon rejects Oothoon's freely given love, and that mocks at any "labour" not quantified within a system of exchange or "payment" (8:8). This economic theme runs throughout the paragraph and is intertwined with questions of education—that is, the interchange not of goods but of ideas—and the now familiar issue of the irreducible varieties of experience. To "take the ape / For thy councellor" or a "dog" for a "schoolmaster" (8:8–9) would seem foolish, as two of the "Proverbs of Hell" make clear: "The eagle never lost so much time. as when he submitted to learn of the crow" and "The apple tree never asks the beech how he shall grow, or the lion. the horse; how he shall take his prey" (*The Marriage of Heaven and Hell*, E37). The point in *Visions* is not the superiority of human to animal intelligence but the uniqueness of each species. Oothoon then implies, with an almost proto-Marxist instinct, that the different economic interests of the critic, the "giver of gifts," the "merchant," the "citizen" (that is, the city dweller), and the "husbandman" (the farmer) determine their different ways of seeing "the world" (8:12–16). Once again, Oothoon celebrates differences, but this time as part of a social critique in which she clearly favors the downtrodden. We can find similar views in some of Blake's most famous lyrics, including "The Chimney Sweeper" in *Songs of Innocence* and "London" in *Songs of Experience*.

Although slavery was not permitted in Blake's England, other reductions of human to economic values were tolerated, even encouraged, by church and state. These supply Oothoon with examples of institutionalized violence akin to her rape. The "fat fed hireling with hollow drum" who "buys whole cornfields into wastes" (8:15–16) appears to be a composite of military recruiters, notorious in Blake's time for their "press gangs" who tricked (or simply forced) men into the army or navy; land agents who would buy farmers' lands and, instead of growing crops, convert the fields into sheep pastures; and gamekeepers who would turn fields into forests for the use of wealthy hunters. Their "eye and ear" (8:16), or at least the minds behind these organs of perception, are indeed different, because those they exploit have completely different interests. The "parson[s]" of the established church are similarly implicated in this cycle of destruction, using legal and religious "nets & gins & traps" to extract tithes from "the labour of the farmer" (8:17–18).[40] These "cold floods of abstraction," the economic and theological equivalents of abstract, or Urizenic, law, generate "forests of solitude" rather than a human community (8:19). Converting the labor of the farmer into money (itself a symbolic abstraction), both "kings & priests" build their "castles and high spires" as architectural expressions of their dominion (8:20).

⁓

Oothoon's speech takes another turn at 8:21 as she moves from general economic criticism to the lot of women. The sexually awakened female, reminiscent of Oothoon herself after she "plucked Leutha's flower" (3:5), is initially free to express her desires, but she is "bound" in an arranged, economically motivated marriage ("spells of law") to "one she loaths" (8:21–22). She is then expected to have sex with her husband, but lacking love, that duty becomes a "weary lust" warped into "murderous thoughts" (8:23). The life force becomes deadly, "spring" is transformed to a "wintry rage," as she is forced to bear "terror," "madness," and bondage, the last imaged as a "rod" that recalls the rod or whip of the slavemaster as well as a yoke for bearing burdens over a woman's "shoulders" (8:24–26). Desire becomes "false," a mere "wheel" that the woman is forced to "turn" (8:27). The woman has been turned into a beast of burden in both her daily and her nightly labors, bound to a system that Blake elsewhere images as a mill (for an early example, see *There is No Natural Religion* principle IV, E2).

Even the woman's "womb" (8:27) becomes a cog in that mechanism. This exceedingly harsh critique of marriage as a system of psychic and economic exploitation likens it to the representations of rape and slavery earlier in the poem.

The depths of Oothoon's horrific vision of female/male relationships are plumbed in her description of childbirth. The monstrous marriage gives "birth" to equally monstrous "cherubs in the human form" who either live with their inherited defects and diseases ("pestilence") or die as quickly as a "meteor" (8:27–29).[41] These images offer intensely physical metaphors for the way psychic distortions can be passed from generation to generation. If the child lives, even if a male he will be forced into the bondage of marriage to "one he hates" and required to engender yet more children (8:30–31). The final two lines of the verse paragraph, if we can read "his" in line 32 as a reference to the "birth" rather than the father, suggest that this final child is born premature ("unripe birth") and blind, unable to see "the arrows of the day" (8:31–32). The cycle of deformity and despair traced in these lines depends on the same compounds of sexual, anatomical, and generational imagery also deployed in the final quatrain of "London" (*Songs of Experience*, E27) and most fully developed in Blake's manuscript poem of c. 1803, "The Mental Traveller" (E483–86).

Oothoon's words continue to tumble one upon another, devoid of the usual logical, and in some cases even grammatical, connective terms. The compressed syntax lends further density to the rapid flow of compound metaphors, leaving us uncertain as to the relationship between vehicle and tenor, between the literal and the figural, in much of her imagery. It is tempting to attribute this near riot of language to Oothoon's traumatized condition, one close to hysteria, generally believed in Blake's time to be caused in women by a disturbance in the uterus. Her references to terrible pregnancies and births accord with this theory. We find, however, these same linguistic patterns in a great deal of Blake's poetry, from 1793 to his last great work, *Jerusalem*. If there is a

degree of madness to this language, it would appear to be a product of Blake's own *furor poeticus* as much as a way of characterizing Oothoon's psychic state.

The final verse paragraph on plate 8 is preceded by a vignette picturing a woman lying facedown on what appears to be a pillow that, in the Huntington copy, is colored the same shade of lavender as the cloak or blanket covering her legs and hips. The undulating line trailing toward the left margin resembles the figure's hair but appears to be an odd extension of the pillow. At this point in the poem, it would be reasonable to identify this figure as Oothoon, perhaps weeping in the midst of her lamentations. Above, and seemingly growing from "O Urizen" in the third line of text, a grape vine acts as a paragraph divider and spirals around the right margin of lines 3 through 6. The immediate textual context offers no clear indication of the motif's meaning: Does it suggest the empty turnings of Urizenic reasoning, or is it an emblem of the fruitful "joys" and "Love" celebrated at the end of the verse paragraph (8:3–6)? The uncertainty matches the emotional range of Oothoon's speech.

Below the vignette, Oothoon returns to her earlier concern with the senses and the behavior of animals. The interrogative mode again predominates. Given Oothoon's (or, to give credit where it is due, Blake's) previous implications about the varieties of life, the questions become rhetorical. The "whale" does not "worship" the "dog" (8:33)—and thus humans should not turn their lesser faculties (reason) into gods (Urizen), and society should not turn dogs (Bromion) into their masters. The whale does not (to state the obvious) "scent the mountain prey," because he is a creature of the "ocean" (8:33–34). For all his might, he cannot see "the flying cloud" as does the "raven," nor can he "measure" the air like the "vulture," because his vision is limited to the watery world his senses perceive and thus, for his mind, create (8:35–36). Even if the "spider" shares cliffs with the "eagle," they are not, perceptually, the same cliffs (8:37). The mole, eagle, and worm (8:39–41) all live in different sensate worlds. The first two of these

three animals again recall the "Motto," also addressed to perspectival differences, in *The Book of Thel*.

FIFTH OPENING: PLATES 9 AND 10

The "worm," in all its lowliness on the chain of being, can build a "pillar" in the graveyard (8:41). Oothoon, at the top of plate 9, builds on this simple image, seeing it first as a "palace of eternity" and then as an emblem of eternal life even in the "jaws of the hungry grave," perhaps another version of the "great mouth" of 8:7. The inscription on the worm's porch—"Take thy bliss O Man!" (9:2)—initiates a *carpe diem* theme that extends through the next few lines. Images of birth and childhood, distorted into the horrors of plate 8, now take on their more traditional associations: renewal, joy, innocence. To this, Oothoon adds infantile sexuality; the "weary lust" (8:23) of adult bondage returns to "fearless, lustful, happy" pleasures (9:4–5) like those Oothoon sought just before her rape. At this point, however, the villain is not Bromion but a subtler form of social coercion. Modesty, as noted earlier, was a central issue for Wollstonecraft, and she, like Oothoon in this passage (9:7–11), found that the virtue was all too often imposed on women, or used by them as an "artful veil of wantonness" and a form of "dissimulation."[42] *Visions* is particularly close to Wollstonecraft's *Vindication* at this juncture, but similarities should not obscure important differences. For Oothoon, modesty itself, not just its hypocritical imitation, is a form of dissimulation and repression. Wollstonecraft's central concern is with the ways women's minds are denied education and their bodies turned into objects of masculine desire. Oothoon, quite to the contrary, emphasizes the ways women are denied free expression of their sexuality.

When viewed from Oothoon's transformative perspective, virginity can be blissful and joyous (see 9:6, 11) because the female has not (yet) been delimited by the economy of masculine sexuality. But the innocent child, once taught the arts of "subtil modesty," will be forced to make her sexual pleasure a "secret" (9:7). The suppression of sexual pleasure among one class of women forces another into prostitution in response to male desires. And if not literal prostitution, then more egregious (but more socially acceptable) forms of dissimulation are marshaled in the battle of the sexes to trap a man into marriage. The image of the "night pillow" (9:11) reminds us of the vignette on the previous plate and suggests an identification of the figure other than Oothoon. She is the woman who finds not only sorrow beneath her pillow but also the psychic "nets" with which she will entrap her own "virgin joy" and "sell it in the night" (9:11–12). The interconnections between sexual and economic exploitation once again come to the fore. Much as Bromion calls Oothoon a "harlot" and stamps his "signet" on his slaves (4:18, 21), women victimized by the ideology of modesty are "brand[ed] with the name of whore" (9:12) if they show any evidence of their sexual natures.

Like the narrator on plate 5, Oothoon turns to institutionalized religion as a main cause of repression and its harmful consequences. As we learn from one of the "Proverbs of Hell" in *The Marriage of Heaven and Hell*, "Prisons are built with stones of Law, Brothels with bricks of Religion" (E36). The "honest" fires of desire are twisted into the "smoky fires" of religious ceremony (9:14–15). The imagery of light and dark, day and night, sleep and wakefulness, is particularly intense in this verse paragraph as the morning of bliss descends into the libidinal night, the cloak of darkness under which the erotic finds its deformed expressions, religious and economic.

Oothoon returns to her immediate situation and once again addresses Theotormon, asking him if what he desires is the "hypocrite modesty" she has analyzed so devastatingly (9:16). Long before Freud's legendary question, "What do women really want?" Blake's Oothoon asks "What do men really want?" The adjectives characterizing innocent sexuality strung together in lines 4–5 —fearless, lustful, happy, honest, open—are matched by their opposites in line 17: "knowing. artful. secret. fearful.

cautious." The latter sort of woman is "a whore indeed" and a "selfish" and "crafty slave" to dissimulation, even if such artful modesty represents itself as a form of "holiness" (9:18–20). Men who demand this hypocrisy from women are projecting on to them a "sick" image constructed in their dreams (9:19).

Oothoon refuses to comply, committing herself instead to "joy," "beauty," and "happy copulation" in a world of the "morning sun" (9:22–32, 10:1). The two designs that interrupt this passage, bottom of plate 9 and top of plate 10, offer a sharp contrast to Oothoon's words and return us to a world of pain and sorrow. The clouds in both pictures suggest occluded vision; the setting on plate 9 accords with the airy abstractions of Urizenic reason. The woman lower right in the first scene is almost certainly Oothoon, her face sunk into her hands, her body turned away from the male as she strides to the right. The association between Bromion and the rod and whip has been well established in the text, but the immediate textual context of plate 9 suggests that the man seated on a cloud may be Theotormon. This identification lends an added dimension to the characterization of Theotormon throughout the poem and, more generally, of masculine desire. The spiky outlines of "Leutha's flower[s]" on plate 3 have become the spiky terminals of the man's lash, poised above his head. Is he about to strike the woman—or himself? The uncertainty in the position of his left arm offers a visual analogue to the ways androcentric ideologies do violence to women and to the men who enforce such ideologies as well. Flagellation and self-flagellation are part of the same syndrome.

～

The women huddled at the top of plate 10 are the "Daughters of Albion" who hear Oothoon's "woes. & eccho back her sighs" (11:13), visually as well as verbally. One Daughter looks heavenward, as if beseeching the gods for relief. There appear to be five women in the Huntington copy: three prominent figures on the right; one bent over her folded legs lower left, with her head far left and her left arm dangling toward the margin of the

text; and, just behind this fourth woman, three rounded forms representing the lowered head and hunched shoulders of a fifth woman. This last figure is reduced to a form barely identifiable as human, as though she, like Theotormon in the frontispiece, is congealing into a stone.

Blake once again returned to the repertoire of postures on page 74 of his Notebook (figure 1) when composing the design on plate 10. The most prominent woman pictured from the side in the etching is very close to the figure just below the center of page 74. Her companion to the left, also seen from the side, follows the Notebook sketch lower left, just above the demonic head, except for the extended left arm and hand in the etching.

The next verse paragraph begins joyously with what amounts to an invocation to Oothoon's muse, "the moment of desire" (10:3). That moment is first experienced by the woman alone, while she "pines for man" (10:4), much as Oothoon's first sexual awakening may have been without a partner. But the description of these masturbatory pleasures contains the seeds of their darker, inward-looking tendencies, for they unfold in the "secret shadows of her chamber" (10:5). Although the suggestion may shock even modern sensibilities, perhaps the woman pictured on plate 8 is masturbating, or suffering from post-masturbatory melancholy. The male "youth" experiences an equivalent frustration when "shut up from / The lustful joy," and will create in his own mind a substitute "amorous image" for the purpose of ultimately unsatisfying self-gratification (10:5–6). He will "forget to generate" (10:6), preferring shadows, secrecy, and silence to sexual contact with another person. Blake's criticism of masturbation is based not on a puritanical disapproval of sexuality, but rather on a sense that sex should be an engendering, outward-moving impulse seeking shared pleasures.

Oothoon turns to religion as a consequence, not only a cause (see 9:14-15), of sexual repression. The ironic "rewards of continence" (10:8) include a perverse pleasure in denying one's sexuality by finding that sexual "acts are not lovely" (10:10) and turning such denials into religious codes that are merely the inverted "reflec-

tions of desire" (10:11).[43] The psychic energy of sex, when thwarted, finds other channels for its expression. Oothoon's critique is a remarkable harbinger of Freud's analysis of the causal connections between individual minds and cultural dynamics in *Civilization and Its Discontents*, first published in 1930. For Oothoon, those alternative modes of expression take destructive forms such as rape, or the volcanic eruptions of plate 5, or the chains of slavery, economic exploitation, modesty, and religions that abstract the soul from the body. As "The voice of the Devil" tells us in *The Marriage of Heaven and Hell*, "All Bibles or sacred codes" have been the cause of the error "That Man has two real existing principles Viz: a Body & a Soul"; but the contrary is "True": "Man has no Body distinct from his Soul for that calld Body is a portion of Soul discernd by the Five Senses" (E34). By asserting the rights of the body, Oothoon expands the definition of "soul" beyond the limitations of the rational, repressed, and hegemonic mind of androcentric culture.

Oothoon again addresses Urizen, now named as the "Father of Jealousy" (10:12).[44] This is literally (and proleptically) true in the sense that he binds both his son (plate 20) and himself (pictorially on plate 21) with the "Chain of Jealousy" (E80) in *The Book of Urizen*. For Blake, jealousy was especially pernicious, having more to do with property rights than love. Earlier, both Bromion and Theotormon had been associated with jealousy (4:19, 5:4); Oothoon now decries her lover's bondage to it. Jealousy has so "darken'd" his vision that Theotormon can see Oothoon only as a "shadow" (10:14–15), as a projected epiphenomenon of his own mental state. In turn, Oothoon, who has tried to establish her identity through a relationship with Theotormon and through his perception of her, sees herself as thoroughly marginalized, even on a metaphysical (not simply a cultural) level. She feels herself to be hovering, a wailing shadow, on the brink of "non-entity" (10:15).

With a radical shift in emotion and perspective of the sort marking several transitional moments in *Visions*, Oothoon returns, at 10:16, to the celebration of love briefly expressed at the beginning of plate 9. This love is "free" and not hindered by the "jealousy" that reduces Theotormon to ineffectual "weepings" and absorbs Oothoon's love like a "sponge" without responding to that love (10:16-18). As in the classical myth of Tantalus, "fruit ... hangs before his sight," but the "web of age" that has darkened Theotormon's mind and heart turns desire into its "sicken[ed]" opposite (10:19–20). This jealous self-absorption is "self-love"; its personification is a "skeleton," deadly to all desire around a "frozen marriage bed" (10:21–22).

Oothoon proposes a disconcerting cure for Theotormon's constrained passions in the next verse paragraph. She will "catch" for him "girls" with "silken nets and traps of adamant" and then view "their wanton play" (10:23–25). We have already witnessed the way in which nets are associated with economic and psychic imprisonment (see comments above on 8:18, 9:11, and note 40). "Adamant" associates Oothoon's plans with the stony character of Bromion's cave and the rigid laws of Urizen. Why does Oothoon turn to such stratagems to please Theotormon, and why does she assume the typically male role of the observer of sexual activity rather than the observed? The possible answers are several; none is completely satisfactory. The pathos of Oothoon's expressions is evident—the desire to do anything to elicit a response from the man she loves. Taking the ideological bearings of Oothoon's words is more puzzling. It seems as though Blake has given to his female hero the very desires that characterize his villains: entrapment, domination, and masculine sexuality in its most specular, objectifying form.[45] This reading brings to our attention a problem that has haunted much of the foregoing commentary: to what extent is Oothoon a fictive character that should not be identified with Blake's own ideas, and to what extent is she a mouthpiece for his thoughts? If we attribute to Blake the sexual sentiments of this passage, then he seems, at least from a late-twentieth-century perspective, to have projected a typically masculinist fantasy onto a female character. Alternatively, however, the modern critic can explain this passage as Blake's characterization of a woman who

has (wrongly) internalized the values and desire of the males who have victimized both her body and her consciousness. But to give this passage its most positive, life-enhancing reading, one can perceive within Oothoon's expressions an attempt to obviate any implication of possessiveness and jealousy, as she directly claims in 10:28–29. By taking the active, male role, she is seizing power for herself. Perhaps she has absorbed but transcended male sexuality to the extent that she can imitate and even parody it.

SIXTH OPENING: PLATE 11

Oothoon continues to juxtapose the imagery of sunlight and clouds on the final plate of *Visions*. The miser's "gold" (11:1) is not the gold of the sun, nor presumably the "girls . . . of furious gold" (10:24) Oothoon has offered to Theotormon. The miser will not see the "beam" of light that, Oothoon hopes, will expand Theotormon's vision to include "pity" (11:2–3). That same beam will scare away the creatures of darkness (11:5). Oothoon next turns to another group of exemplary animals, those who convert adversity (the "wintry blast," the "pestilence," 11:6–7) to their own advantage, just as Oothoon has been trying to reconfigure her violation into a revival. She ends her speech on a high note of universal "joy" with a bold proclamation: "for every thing that lives is holy!" (11:10). Blake, at least at his own more optimistic moments, concurred, for he used the same ringing phrase as the final line in the revolutionary "Song of Liberty" that concludes *The Marriage of Heaven and Hell* of 1790 and, in the same year as *Visions*, he used it again at an equally revolutionary moment in *America*. Both contexts help us understand the significance of the phrase in *Visions*.

In *The Marriage*, "For every thing that lives is Holy" (E45) is preceded by a reference to "religious letchery" that perverts unacted desire into a supposedly positive value, "virginity." This is the same error that occurs in *Visions* when the "self enjoyings of self denial" are institutionalized into a "religion" (10:9). In *America*, the ringing phrase is uttered by Orc, the fiery revolutionary. The inversions and hypocrisy of "religious letchery" are again referenced, but these are now accompanied by additional statements that resonate with *Visions*:

> That pale religious letchery, seeking Virginity,
> May find it in a harlot, and in coarse-clad honesty
> The undefil'd tho' ravish'd in her cradle night and
> morn:
> For every thing that lives is holy, life delights in life;
> Because the soul of sweet delight can never be defil'd.
> (E54)

Orc here summarizes Oothoon's fundamental claim that her value, to herself and to others, cannot be diminished by the related tyrannies of physical violence and religious repression. The "soul of sweet delight" can "never pass away" (Oothoon in *Visions* 4:9–10), nor can it be "defil'd" (Orc in *America*). In the speech quoted above, Orc reveals himself as a male equivalent of Oothoon; in turn, the parallels in diction and theme indicate the extent to which Oothoon is the female voice of revolution.

In the context of *Visions*, one might well ask if the holiness of "every" living thing includes the likes of Bromion and Theotormon. The answer is "yes" if we adopt the Blakean view that errors in the way we see things in the world of time and space create evil. If we see "every thing" from the perspective of infinity and eternity—a perspective closed to Bromion and Theotormon but to which Oothoon aspires—then all of life is indeed holy (indeed, "every thing" is alive). Blake makes this same basic point in *The Marriage of Heaven and Hell* when he calls for humanity's return to paradise. Then "the whole creation will be consumed, and appear infinite. and holy whereas it now appears finite & corrupt. . . . If the doors of perception were cleansed every thing would appear to man as it is: infinite" (E39). For Blake and for Oothoon, any revolutionary change in society, including an alteration in the way men relate to women, is predicated upon this revolution in vision.

Theotormon does not reply to Oothoon's long concluding speech. He remains as he is pictured on the frontispiece and on plate 7, sitting on the margin of the "ocean," conversing not with Oothoon but with the "shadows dire" of his enclosed mind (11:12). Only the Daughters of Albion have heard Oothoon, and even they can only "eccho back her sighs" (11:13). This is surely something less than the interactive conversation sought by Oothoon. We are left in a world of shadows and echoes yet to be—perhaps never to be—transformed by Oothoon's words and desires. We are left in the gap between appeal and response, between rhetoric and communal action. Yet perhaps the foundation for cultural transformation has been laid in the form of Oothoon's expanding insight that, even if not completely free from the ideology she opposes, has been the central energizing force throughout the poem.

The text concludes, but not the work. We see below (and beyond?) "The End," Blake's final illustration. The Daughters of Albion huddle together near the sea. Two look above, where they see Oothoon hovering in front of clouds, her outstretched arms lapped by flames. Her face, with heavy and downward-arching brows, is marked by woe or worse. The Daughters, like Theotormon in the text on this plate, sit "upon the margind ocean," their echoing of Oothoon's words an auditory equivalent of his "conversing with shadows" (11:12).

The preliminary drawing for the concluding design appears on page 78 of Blake's Notebook (figure 9). The etching omits the suggestion of rain (below the cloud on the right in the sketch) and the crescent moon above the head of the Daughter far left. Oothoon's mouth is clearly open in the sketch, but it is closed in the Huntington impression and, very probably, on the copperplate. Several other copies of *Visions* (for example, copies C, F, G, O, and R) include slight inking differences or hand coloring similar to the drawing in this respect and thus indicate that Oothoon is speaking.

Blake may have developed his final representation of Oothoon from the soaring figure, center left, on page 74 of his Notebook (figure 1). There are major differences and exclusions, including the arm position, the curving drapery, and the lightning bolt on page 74, but these points of departure do not disrupt the general similarities in situation and emotional suggestion. The slight indications of a crescent moon below the lightning on page 74 may have prompted the similar shape in the preliminary sketch on page 78. At the very least, Blake would seem to be in pursuit of the same expressive iconography in both drawings.

Are the Daughters of Albion on the final plate as ineffectual and limited as Theotormon? The design suggests as much, at least in the Daughters' enclosed postures, indicative of their inability to respond creatively to Oothoon. More surprising is the way Oothoon's posture, flames, and facial expression in the design mimic her pursuer on the title page. This resemblance raises some of the same issues we confronted when Oothoon proposed to trap girls for her lover's pleasure (10:23–29). Has Oothoon triumphed, assuming the power of the male demon on the title page, or has she succumbed to the ideology that has tyrannized over her, thereby becoming what she labors against? The answer may be "both"—for Oothoon and for all revolutionaries. Any successful attempt to seize power, even over one's own self-definition, from those in control places the revolutionary in a position previously held by the adversary, thereby replacing the enemy but also making the newly empowered liable to repeat a misuse of power. This cycle of energy and entrapment, only hinted at by the concluding design in *Visions*, will become a leitmotif of Blake's political poems of the mid-1790s.

We are left, at the end of *Visions of the Daughters of Albion*, with several quandaries—cultural, political, psychological, and even metaphysical. But Blake's failure to resolve all the questions his poem raises is an indication of his honesty as a poet and artist and his refusal to be a doctrinaire philosopher. We learn from *Visions* that the immediate issues of rape, slavery, and exploitation have roots as deep as the mind itself. Blake's descent into those

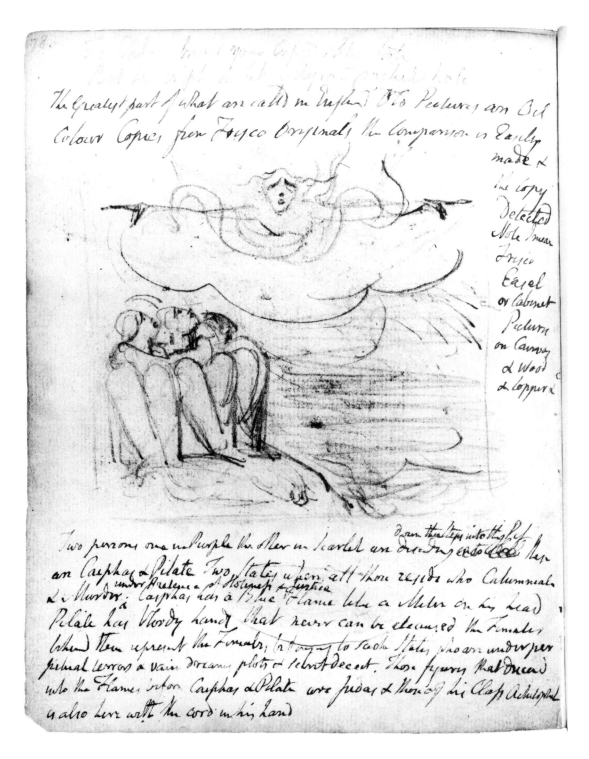

Figure 9. Blake's Notebook, page 78, preliminary drawing for plate 11

depths will run throughout his later poetry, concluding in the great ascent at the end of *Jerusalem*. In that post-apocalyptic world, Oothoon's most expansive hopes will be realized. There all "Embraces are Cominglings: from the head even to the Feet" (E223); there all men and women will converse

> . . . together in Visionary forms dramatic which
> bright
> Redounded from their Tongues in thunderous
> majesty, in Visions
> In new Expanses, creating exemplars of Memory
> and of Intellect
> (E257–58)

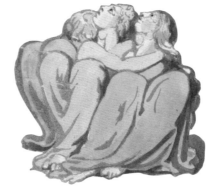

Notes to the Commentary

1 Gilchrist, *Life of William Blake* (London and Cambridge: Macmillan, 1863), 1:70. Blake was the first to refer to his works as "Illuminated Books," in his advertisement "To the Public" of October 1793; see *The Complete Poetry and Prose of William Blake*, newly revised edition, ed. David V. Erdman (New York: Doubleday, 1988), 693. *Visions of the Daughters of Albion* is quoted from the text as printed in the Huntington copy and transcribed in this volume (with references by plate and line number); all other writings by Blake are quoted from the Erdman edition, hereafter cited in the text as "ᴇ" followed by page number.

2 Facts about Blake's life are based on Gilchrist's *Life of Blake* (see note 1, above) or on documents and early biographies printed in G. E. Bentley Jr., *Blake Records* (Oxford: Clarendon Press, 1969).

3 Smith, *Nollekens and His Times* (1828), reprinted in Bentley, *Blake Records*, 460. Gilchrist, in *Life of Blake* 1:68–70, offers a more dramatic description, probably based on Smith's account.

4 For more detailed descriptions of Blake's special graphic techniques, see Robert N. Essick, *William Blake Printmaker* (Princeton: Princeton University Press, 1980); and Joseph Viscomi, *Blake and the Idea of the Book* (Princeton: Princeton University Press, 1993).

5 Blake's relief-etched copperplates have been lost except for a fragment of a canceled plate from the illuminated book *America* (1793). This shows very shallow etching with a differential between the relief plateaus and the etched valleys of only .12 mm. It seems likely that Blake first etched his plates more deeply than necessary, but learned in the course of production that shallow etching would permit acceptable inking and printing. The *America* copperplate fragment, now in the National Gallery of Art, Washington, D.C., also shows step etching, a technique used to protect small relief areas with additional varnish part way through the etching process. Blake probably used this procedure in *Visions of the Daughters of Albion* as well.

6 Blake used sized preliminary drawings, prepared for transfer facedown to the surface of the copper, for plates executed wholly or primarily in white-line etching. Extant sketches for relief-etched designs, such as those found in Blake's Notebook, would appear to be first thoughts on paper and are far less developed than what is required for

intaglio work. The Notebook versions of some of Blake's poems subsequently etched in relief are working drafts, not fair copies.

7 *Pilgrim's Progress* can be described as an allegorical text that includes its own explication since the tenors of its vehicles are explicitly indicated. This degree of self-explanatory clarity hardly ever appears in Blake's works.

8 For information on the Huntington copy, see the "Bibliographic and Textual Notes" following the transcription of the poem, above.

9 Intaglio etching/engraving and woodcut are as capable of integrating text and design as Blake's method of relief etching. The unusual features of Blake's work are not dependent on absolute physical differences between his medium and more conventional processes, but rather on his divergence from bibliographic conventions that determined how those standard processes were deployed. Etched title pages were not uncommon in the late eighteenth century, but they tended to maintain a spatial separation between text and picture.

10 The classical sculpture is reproduced in Bernard de Montfaucon, *Antiquity Explained* (London, 1721), vol. 1, facing p. 25. Other borrowings from this standard study of classical art indicate that Blake was probably familiar with its many engraved illustrations.

11 See John Knowles, *The Life and Writings of Henry Fuseli* (London: Colburn and Bentley, 1831), 1:161–70; and William Godwin, *Memoirs of Mary Wollstonecraft*, ed. W. Clark Durant (London: Constable, 1927), 57–62, 182–86.

12 See particularly the commentaries by Damon, Goslee, Peterson, and Vogler listed in the Bibliography, below. Edwin John Ellis and William Butler Yeats were the first to propose that "the motto implies that the artist was not always certain of the meaning or mission of every form that presented itself to him in vision"; see *The Works of William Blake*, ed. Ellis and Yeats, 3 vols. (London: Bernard Quaritch, 1893), 2:353.

13 See the texts of "Oithona" and "Barrathon" in Macpherson, *Fingal . . . with Several Other Poems, Composed by Ossian* (London: T. Becket and P. A. De Hondt, 1762).

14 See, for example, Jacob Bryant, *A New System, or, an Analysis of Ancient Mythology*, 3 vols. (London: T. Payne, et al., 1774–76). Blake very probably participated in the production of the engraved illustrations for these volumes while an apprentice in James Basire's shop. In his *Descriptive Catalogue* of 1809, Blake states that "the antiquities of every Nation under Heaven, is no less sacred than that of the Jews. They are the same thing as Jacob Bryant, and all antiquaries have proved" (E543). For general studies of the structure and historical implications of Blake's names for his mythic characters, see Vincent A. De Luca, "Proper Names in the Structural Design of Blake's Myth-Making," *Blake Studies* 8 (1978): 5–22; and Robert N. Essick, *William Blake and the Language of Adam* (Oxford: Clarendon Press, 1989), 210–16.

15 Wollstonecraft, *A Vindication of the Rights of Woman*, ed. Carol H. Poston, 2d ed. (New York: W. W. Norton, 1988), 125.

16 Gregory, *A Father's Legacy to His Daughters*, 6th ed. (Dublin: J. Colles, 1774), 36. Blake's friend Thomas Stothard illustrated a new edition of Gregory's book in 1797.

17 See Macpherson, *Temora . . . with Several Other Poems, Composed by Ossian* (London: T. Becket and P. A. De Hondt, 1763), 211.

18 See Moira Ferguson, *Subject to Others: British Women Writers and Colonial Slavery, 1678–1834* (New York: Routledge, 1992).

19 Wollstonecraft, *Vindication*, 189.

20 *The Botanic Garden*, part 2, "The Loves of the Plants" (Lichfield: J. Johnson, 1789), 183.

21 On "nympha," see the *OED* for examples in medical texts published between 1693 and 1863. The possibility of medical references in Blake's poetry is buttressed by his experiences engraving plates for several medical books published by Johnson in the early 1790s and by the exploration of human anatomy central to the creation myth of Blake's *The Book of Urizen* (1794).

22 The marigold is sometimes identified as the flower in the classical myth of Clytie, who was changed into a heliotropic flower because of her faithful love for the sun god, Apollo (see Ovid's *Metamorphoses*, book 4). Darwin (see note 20, above) mentions heliotropism (p. 19); Blake treats the phenomenon as a symbol of unfulfilled longing in "Ah! Sun-Flower" (*Songs of Experience*, E25).

23 See Anna Clark, *Women's Silence, Men's Violence: Sexual Assault in England, 1770–1845* (New York: Pandora, 1987).

24 In Blake's later poetry, and probably in the passage from *The Book of Thel* quoted earlier, curtains, mantles, and veils are almost always negative images of coverings that block the free expression of desire, sexual or spiritual. The curtains surrounding the Ark of the Covenant in the Old Testament were, for Blake, particularly suspect in this regard, for they transformed God's words into a mystery hidden to all but priests. In Blake's final epic, *Jerusalem*, this "Veil the Saviour born & dying rends" (E204).

25 John Gabriel Stedman, *Narrative, of a Five Years' Expedition, Against the Revolted Negroes of Surinam* (London: J. Johnson and J. Edwards, 1796), 1:206; hereafter cited in the text by volume and page number.

26 Stedman's original manuscript is printed in his *Narrative*, edited by Richard Price and Sally Price (Baltimore: Johns Hopkins University Press, 1988). Blake's personal contacts with Stedman, and the fact that he began to execute engravings for the book about five years before its publication, suggest that he may have seen, or known details from, the manuscript. For reproductions of, and comments on, Blake's engravings based on Stedman's drawings and published in his *Narrative*, see Robert N. Essick, *William Blake's Commercial Book Illustrations* (Oxford: Clarendon Press, 1991), 71–75, and figs. 155–70.

27 I use this and similar phrases to indicate how Blake is exploring sexual and economic metaphors that continue to influence the rhetoric and perception of sexual politics in our own time.

28 The treatment of women as a medium of interchange among men is explored, on a theoretical level, in Luce Irigaray, *This Sex Which Is Not One*, trans. Catherine Porter (Ithaca: Cornell University Press, 1985). Irigaray, converting the structural anthropology of Claude Lévi-Strauss into a feminist perspective, claims that "woman exists only as an occasion for mediation, transaction, transition, transference, between man and his fellow man, indeed between man and himself" (192–93).

29 The volcanic imagery in this passage (5:9–10) may have been suggested to Blake's metaphoric mind by Mt. Vesuvius, particularly the series of major eruptions in 1776–79 described and pictured by visiting Englishmen. The interweaving of anatomical, psychological, and geological imagery becomes a major dynamic in Blake's later creation myths, beginning with *The Book of Urizen* in 1794.

30 A contemporary parallel is provided by Stedman's description of a tortured slave with "vultures . . . picking in the putred wound." This reference does not appear in the published edition of Stedman's *Narrative* but only in his manuscript; see the Price and Price edition (note 26, above), 103.

31 According to Henry Crabb Robinson's diary, Blake "spoke of the Atonement" on 7 December 1826 and "Said—it is a horrible doctrine—If another man pay your debt I do not forgive it" (*Blake Records* [note 2, above], 337). See also *Jerusalem* 61:15–21, where Blake calls the supposedly "tender Mercies" of atonement "Cruelty" (E211–12).

32 Wollstonecraft, *Vindication,* 71–72.

33 The characterization of Theotormon's ineffectual behavior may have been influenced in part by Stedman's inability to free from slavery the woman with whom he fell in love. As he writes in one telling passage, "I fancied I saw her tortured, insulted, and bowing under the weight of her chains, calling aloud, but in vain, for my assistance" (1:208).

34 On Blake's use of oral-formulaic structures, see Essick, *Blake and the Language of Adam,* 172–79. For Lowth's possible influence, see John Howard, *Infernal Poetics: Poetic Structures in Blake's Lambeth Prophecies* (London and Toronto: Associated University Presses, 1984), 97–110.

35 Locke's basically similar claim appears in his *Essay Concerning Human Understanding* (1690): "had Mankind been made with but four Senses, the Qualities then, which are the Object of the Fifth Sense, had been as far from our Notice, Imagination, and conception, as now any *belonging to a Sixth, Seventh, or Eighth Sense.*" See Locke, *Essay Concerning Human Understanding,* ed. Peter H. Nidditch (Oxford: Clarendon Press, 1975), bk. 2, chap. 2, par. 3.

36 The African child in Blake's "The Little Black Boy" makes the same point, although with racial implications that have disconcerted modern readers, when he says that "I am black, but O! my soul is white" (*Songs of Innocence,* E9).

37 By "motivated" I mean that Oothoon, and by implication her creator, envisions a real, and not merely a fanciful or decorative, connection between the material vehicles and the mental or emotional tenors of her metaphors. This attitude toward poetic language (however mistaken it may be from a rationalist perspective) recalls the doctrine of correspondences between the natural and spiritual worlds propounded by Emanuel Swedenborg (1688–1772). Although Blake announced his rejection of Swedenborg in *The Marriage of Heaven and Hell* (1790), the writings of the Swedish mystic influenced Blake's later works.

38 Bromion's reference to "trees and fruits" (7:14) may have been suggested by Stedman's accounts of exotic flora in Surinam. Blake engraved one of several plates picturing such fruits, which, according to Stedman, had unusual flavors that gratified his palate (if not quite "senses unknown"; 7:15).

39 The imaginative etymological origins and punning meanings of "Urizen" may include the Greek word for "bound" or "terminate" from which "horizon" derives, usually transliterated as "ourizein"; "your reason"; "ur-reason," meaning the original or "ur" form of reason; "err-reason" (the errors of excessive rationality); and "your eyes in" (possibly "in" the cave/skull of the delimited human body and mind).

40 Compare to one of the "Proverbs of Hell" in *The Marriage of Heaven and Hell* ("All wholsom food is caught without a net or a trap," E36) and to *The Song of Los* ("These were the Churches: Hospitals: Castles: Palaces: / Like nets & gins & traps to catch the joys of Eternity," E67).

41 Blake's interest in meteors or "shooting stars" (see the separate plate, "The Approach of Doom," and plates 29 and 33 in *Milton a Poem*) was probably stimulated by the great meteor of 18 August 1783, which caused a sensation in London. See Robert J. M. Olson and Jay M. Pasachoff, *Fire in the Sky: Comets and Meteors, the Decisive Centuries, in British Art and Science* (Cambridge: Cambridge University Press, 1998), 80–101.

42 Wollstonecraft, *Vindication,* 193.

43 As an engraver, who must constantly conceive and perceive images on copperplates as the reverse of what will appear in prints made from those plates, Blake made extensive use of right/left reversals (or "bilateral inversion") in his pictorial and verbal imagery. The reversal or inversion of psychic orientation in Blake's poetry is part of this extensive array of right/left (and, by extension, up/down) shifts from innocence to experience, positive to negative, expression to re-

pression, energy to bondage. In Blake's universe, every concept, like a coin, has two sides; much of his poetry investigates the movement from one side to another.

44 Blake based several features of Urizen's character on the God of the Old Testament, who refers to himself as "a jealous God" in Exodus 20:5. Blake's criticism of jealousy may have a biographical context. According to Gilchrist in *Life of Blake* (see note 1, above), at one point in their marriage Mrs. Blake suffered from "jealousy . . . not wholly unprovoked" (1:316).

45 In April 1789, Blake and his wife attended an organizational meeting of a church based on Swedenborg's writings (see note 37, above). At about the same time, Blake annotated two of Swedenborg's books and probably read several others. One of the main controversies in the Swedenborgian church of London was over the issue of concubinage—that is, whether or not the Bible authorized a man to take multiple sexual partners. Thus, Oothoon's offer to provide her lover with several "girls" for his gratification may reflect Blake's meditations on this controversy. In May 1826, Blake told Henry Crabb Robinson that the Bible advocated a community of wives (see Bentley, *Blake Records* [note 2, above], 332). On the basis of unknown evidence, William Michael Rossetti claimed that "it has even been said that at one time [Blake] proposed to add a second wife to the household"; see Rossetti, "Prefatory Memoir" in *The Poetical Works of William Blake*, ed. Rossetti (London: Bell, 1874), xxiii. If true, this may have been the cause of Mrs. Blake's jealousy (see note 44, above).

INDEX TO THE COMMENTARY

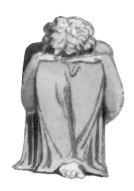

Bibliography

Studies of *Visions of the Daughters of Albion*

Aers, David. "Blake: Sex, Society, and Ideology." *Romanticism and Ideology: Studies in English Writing, 1765–1830.* Ed. David Aers, Jonathan Cook, and David Punter. London: Routledge and Kegan Paul, 1981. Pp. 27–43.

Aers. "William Blake and the Dialectics of Sex." *ELH* 44 (1977): 500–511.

Allen, Graham. "Blake's *Visions of the Daughters of Albion.*" *Approaching Literature: Romantic Writings.* Ed. Stephen Bygrave. New York: Routledge, 1996. Pp. 217–23.

Anderson, Mark. "Oothoon, Failed Prophet." *Romanticism Past and Present* 8 (1984): 1–21.

Baine, Rodney M. "Bromion's 'Jealous Dolphins.'" *Blake: An Illustrated Quarterly* 14 (1981): 206–7.

Beer, John. *Blake's Humanism.* Manchester: Manchester University Press, 1968. Pp. 40–46.

Behrendt, Stephen. *Reading William Blake.* New York: St. Martin's, 1992. Pp. 84–93.

Bindman, David. "Blake's Vision of Slavery Revisited." *Huntington Library Quarterly* 58 (1996): 373–82.

Blake, William. *The Early Illuminated Books.* Ed. Morris Eaves, Robert N. Essick, and Joseph Viscomi. London: William Blake Trust and Tate Gallery, 1993. Pp. 225–78.

Bracher, Mark. "The Metaphysical Ground of Oppression in Blake's *Visions of the Daughters of Albion.*" *Colby Library Quarterly* 20 (1984): 164–76.

Bruder, Helen P. *William Blake and the Daughters of Albion.* Basingstoke: Macmillan, 1997. Pp. 72–89.

Butler, Gerald J. "Conflict between Levels in Blake's *Visions of the Daughters of Albion.*" *Recovering Literature* 6, no. 2 (1976): 39–49.

Chapman, Wes. "Blake, Wollstonecraft, and the Inconsistency of Oothoon." *Blake: An Illustrated Quarterly* 31 (1997): 4–17.

Cherry, Charles L. "The Apotheosis of Desire: Dialectic and Image in *The French Revolution, Visions of the Daughters of Albion,* and the *Preludium* of *America.*" *Xavier University Studies* 8 (1969): 18–31.

Cherry. "William Blake and Mrs. Grundy: Suppression of *Visions of the Daughters of Albion.*" *Blake Newsletter* 3 (1970): 6–10.

Clark, S. H. *Sordid Images: The Poetry of Masculine Desire.* London and New York: Routledge, 1994. Pp. 163–72.

COOKE, Michael G. *Acts of Inclusion: Studies Bearing on an Elementary Theory of Romanticism.* New Haven and London: Yale University Press, 1979. Pp. 107–14.

Cox, Stephen. *Love and Logic: The Evolution of Blake's Thought.* Ann Arbor: University of Michigan Press, 1992. Pp. 113–25.

DAMON, S. Foster. *William Blake: His Philosophy and Symbols.* London: Constable, 1924. Pp. 329–33.

DAMROSCH, Leopold Jr. *Symbol and Truth in Blake's Myth.* Princeton: Princeton University Press, 1980. Pp. 197–202.

DUERKSEN, Roland A. "Bromion's Usurped Power—Its Sources, Essence, and Effect: A Replication." *Blake Newsletter* 8 (1974): 95–96.

DUERKSEN. "A Crucial Line in *Visions of the Daughters of Albion.*" *Blake Newsletter* 6 (1973): 72–73.

DUERKSEN. "The Life of Love: Blake's Oothoon." *Colby Library Quarterly* 13 (1977): 186–94.

ELLIS, Helen. "Blake's 'Bible of Hell': *Visions of the Daughters of Albion* and the Song of Solomon." *English Studies in Canada* 12 (1986): 23–36.

ERDMAN, David V. *Blake: Prophet Against Empire.* 3d ed. Princeton: Princeton University Press, 1977. Pp. 228–48.

ERDMAN. "Blake's Vision of Slavery." *Journal of the Warburg and Courtauld Institutes* 15 (1952): 242–52.

ERDMAN. *The Illuminated Blake.* Garden City: Anchor Books, 1974. Pp. 125–36.

FERBER, Michael. *The Poetry of William Blake.* London: Penguin, 1991. Pp. 67–74.

FRYE, Northrop. *Fearful Symmetry: A Study of William Blake.* Princeton: Princeton University Press, 1947. Pp. 238–42.

FULLER, David. *Blake's Heroic Argument.* London: Croom Helm, 1988. Pp. 41–49.

FULLER. Introduction and notes in *Blake: Selected Poetry and Prose*, ed. Fuller. Harlow: Longman, 2000. Pp. 163–82.

GEORGE, Diana Hume. *Blake and Freud.* Ithaca: Cornell University Press, 1980. Pp. 125–44.

GILLHAM, D. G. "Blake: *Visions of the Daughters of Albion.*" *Wascana Review* 3 (1968): 41–58.

GILLHAM. *William Blake.* Cambridge: Cambridge University Press, 1973. Pp. 192–213.

GLECKNER, Robert F. *The Piper & The Bard: A Study of William Blake.* Detroit: Wayne State University Press, 1959. Pp. 198–216.

GOSLEE, Nancy Moore. "Slavery and Sexual Character: Questioning the Master Trope in Blake's *Visions of the Daughters of Albion.*" *ELH* 57 (1990): 101–28.

HAIGWOOD, Laura Ellen. "Blake's *Visions of the Daughters of Albion*: Revising an Interpretive Tradition." *San Jose Studies* 11 (1985): 77–94.

HAMBLEN, Emily S. *On the Minor Prophecies of William Blake.* London and Toronto: J. M. Dent and Sons, 1930. Pp. 202–18.

HARPER, George Mills. *The Neoplatonism of William Blake.* Chapel Hill: University of North Carolina Press, 1961. Pp. 256–62.

HEFFERNAN, James A. H. "Blake's Oothoon: The Dilemmas of Marginality." *Studies in Romanticism* 30 (1991): 3–18.

HILTON, Nelson. "An Original Story." *Unnam'd Forms: Blake and Textuality.* Ed. Nelson Hilton and Thomas A. Vogler. Berkeley: University of California Press, 1986. Pp. 69–104.

HINKEL, Howard H. "From Energy and Desire to Eternity: Blake's *Visions of the Daughters of Albion.*" *Papers on Language & Literature* 15 (1979): 278–89.

HOERNER, Fred. "Prolific Reflections: Blake's Contortion of Surveillance in *Visions of the Daughters of Albion.*" *Studies in Romanticism* 35 (1996): 119–50.

HOWARD, John. *Infernal Poetics: Poetic Structures in Blake's Lambeth Prophecies.* London and Toronto: Associated University Presses, 1984. Pp. 97–108.

JACKSON, Mary V. "Additional Lines in *VDA.*" *Blake Newsletter* 8 (1974-75): 91–93.

LANSVERK, Marvin D. L. *The Wisdom of Many, the Vision of One: The Proverbs of William Blake*. New York: Peter Lang, 1994. Pp. 117–30.

LATTIN, Vernon E. "Blake's Thel and Oothoon: Sexual Awakening in the Eighteenth Century." *Literary Criterion* 16 (1981): 11–24.

LINKIN, Harriet Kramer. "Revisioning Blake's Oothoon." *Blake: An Illustrated Quarterly* 23 (1990): 184–94.

MARGOLIOUTH, H. M. *William Blake*. London: Oxford University Press, 1951. Pp. 44–51.

MELLOR, Anne K. *Blake's Human Form Divine*. Berkeley: University of California Press, 1974. Pp. 58–64.

MELLOR. "Sex, Violence, and Slavery: Blake and Wollstonecraft." *Huntington Library Quarterly* 58 (1996): 345–70.

Moss, John G. "Structural Form in Blake's 'Visions of the Daughters of Albion.'" *Humanities Association Bulletin* 22, no. 2 (1971): 9–18.

MURRAY, E. B. "'Bound Back to Back in Bromion's Cave.'" *Blake Newsletter* 8 (1974): 94.

MURRY, J. Middleton. *William Blake*. London: Jonathan Cape, 1933. Pp. 108–27.

PETERSON, Jane E. "*The Visions of the Daughters of Albion*: A Problem in Perception." *Philological Quarterly* 52 (1973): 252–64.

PUNTER, David. "Blake, Trauma, and the Female." *New Literary History* 15 (1984): 475–90.

PUNTER. *The Romantic Unconscious*. New York: New York University Press, 1989. Pp. 78–83.

RAJAN, Tilottama. "En-Gendering the System: *The Book of Thel* and *Visions of the Daughters of Albion*." *The Mind in Creation: Essays on English Romantic Literature in Honour of Ross G. Woodman*. Ed. J. Douglas Kneale. [Montreal]: McGill-Queen's University Press, 1992. Pp. 74–90.

RAJAN. *The Supplement of Reading*. Ithaca: Cornell University Press, 1990. Pp. 243–52.

REISNER, Mary Ellen. "The Rainbow in Blake's 'Visions of the Daughters of Albion.'" *Notes & Queries,* n.s. 18 (1971): 341–43.

REISNER, Thomas A., and Mary Ellen Reisner. "A Blake Reference to Goldsmith's 'Citizen of the World.'" *Notes & Queries,* n.s. 21 (1974): 264–65.

RUBINSTEIN, Christopher. "'The Eye Sees More than the Heart Knows': Some Possible Hidden Meanings in *Visions of the Daughters of Albion*." *The Journal of the Blake Society,* no. 4 (1999): 66–75.

SPECTOR, Sheila A. *"Wonders Divine": The Development of Blake's Kabbalistic Myth*. Lewisburg: Bucknell University Press; and London: Associated University Presses, 2001. Pp. 53–58.

STEVENSON, W. H. Introduction and notes in *Blake: The Complete Poems*, ed. Stevenson. 2d ed. London: Longman, 1989. Pp. 172–86.

SUMMERFIELD, Henry. *A Guide to the Books of William Blake for Innocent and Experienced Readers*. Gerrards Cross: Colin Smythe, 1998. Pp. 81–87, 392–404.

SWEARINGEN, James E. "The Enigma of Identity in Blake's *Visions of the Daughters of Albion*." *Journal of English and Germanic Philology* 91 (1992): 203–15.

SWINBURNE, Algernon Charles. *William Blake: A Critical Essay*. London: John Camden Hotten, 1868. Pp. 227–34.

VINE, Steven. " 'That Mild Beam': Enlightenment and Enslavement in William Blake's *Visions of the Daughters of Albion*." *The Discourse of Slavery*. Ed. Carl Plasa and Betty J. Ring. London and New York: Routledge, 1994. Pp. 40–63.

VISCOMI, Joseph. *Blake and the Idea of the Book*. Princeton: Princeton University Press, 1993. Pp. 132–42, 290–94, 376–80.

VOGLER, Thomas A. " 'in vain the Eloquent tongue': An Un-Reading of *Visions of the Daughters of Albion*." *Critical Paths: Blake and the Argument of Method*. Ed. Dan Miller, Mark Bracher, and Donald Ault. Durham: Duke University Press, 1987. Pp. 271–309.

WAGENKNECHT, David. *Blake's Night: William Blake and the Idea of Pastoral.* Cambridge, Mass.: Harvard University Press, 1973. Pp. 204–10.

WARDLE, J. "Blake's Leutha." *English Language Notes* 5 (1967): 105–6.

WASSER, Henry H. "Notes on the *Visions of the Daughters of Albion* by William Blake." *Modern Language Quarterly* 9 (1948): 292–97.

WATSON, Alan. "Blake's Frontispiece to the *Visions of the Daughters of Albion.*" *Transactions of the Samuel Johnson Society of the Northwest* 5 and 6 (1972–73): 70–81.

WAXLER, Robert P. "The Virgin Mantle Displaced: Blake's Early Attempt." *Modern Language Studies* 12 (1982): 45–53. WEBER, Dwight E. "Blake's *Visions of the Daughters of Albion*: A Poem Based on Doubt." *Blake: An Illustrated Quarterly* 12 (1978–79): 203–4.

WEBSTER, Brenda S. *Blake's Prophetic Psychology.* Athens: University of Georgia Press, 1983. Pp. 91–109.

WILKIE, Brian. *Blake's Thel and Oothoon.* Victoria, British Columbia: University of Victoria, 1990.

WILLIAMS, Nicholas M. *Ideology and Utopia in the Poetry of William Blake.* Cambridge: Cambridge University Press, 1998. Pp. 85–97.

WORRALL, David. "William Blake and Erasmus Darwin's *Botanic Garden.*" *Bulletin of the New York Public Library* 78 (1975): 397–417.

Designed by Leslie Fitch

Copy edited by Susan Green

Digital imaging by John Sullivan

and Manuel Flores

❧

Printed by CS Graphics, Singapore,

on Book Design Smooth, Klippan AB,

Sweden

❧

A NOTE ON THE TYPE

The body of the text is Minion,

designed by Robert Slimbach.

It was released in digital form

by Adobe Systems,

San Jose, California,

in 1989.

❧

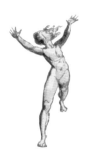